Blind Lemon JEFFERSON

His Life, His Death, and His Legacy

Robert L. Uzzel

EAKIN PRESS ⟁ Fort Worth, Texas

For CIP
information,
please access:
www.loc.gov

This book is dedicated to three outstanding black women from Freestone County, Texas: my wife, Debra Bass Uzzel; her mother, Aldessa Henry Bass; and her aunt, LaVerne Henry Brackens.

Contents

ACKNOWLEDGMENTS .. vii

CHAPTER 1 The Historical Context of the
 Career of Blind Lemon Jefferson 1

CHAPTER 2 Central Texas Years 12

CHAPTER 3 Dallas Years 20

CHAPTER 4 Chicago Years 31

CHAPTER 5 Death of Blind Lemon Jefferson 45

CHAPTER 6 Blind Lemon Jefferson Remembered 50

CHAPTER 7 Legacy of Blind Lemon Jefferson 59

APPENDIX I: 1967 Dedication Program 71

APPENDIX II: 1967 Dedicatory Speech 75

ENDNOTES .. 81

BIBLIOGRAPHY .. 97

INDEX .. 101

ABOUT THE AUTHOR .. 109

Acknowledgments

I have been asked the question "How did you become interested in Blind Lemon Jefferson?" My interest in Lemon began shortly after the beginning of my residence in Freestone County, Texas, in December 1974. At that time, I started work as a social worker for the aged, blind, and disabled, employed by the Texas Department of Public Welfare (which is now called the Texas Department of Human Services). My caseload included clients in Teague (the location of my office), Fairfield (the county seat), Butler, Wortham, Streetman, Kirvin, and various other rural communities. As a lifelong history buff, I immediately began learning about local history, visiting the Burlington–Rock Island Railroad Museum at Teague and the Freestone County Museum at Fairfield. At these facilities, I obtained, respectively, copies of a list of the county's state historical markers and the program for the dedication of the 1967 historical marker above Lemon's grave at the Wortham Black Cemetery. During my first trip to Wortham for home visits, I visited the grave. This was the first of many visits to what has developed into a blues shrine.

When I first moved to Teague, I had no idea that I would establish permanent ties with Freestone County or that research into local history would become such an obsession. On February 19, 1977, I married Debra Bass, a native of Fairfield. We lived in Fairfield for only a few weeks. We then moved to Dallas and later to Kaufman, to Waco, and back to Dallas. Nevertheless, our links to Fairfield and Freestone County remain strong and we hope eventually to retire there. My wife's family tree, which stretches from Freestone County

through Louisiana and South Carolina all the way back to Africa, continues to be a major source of fascination and, hopefully, will be the subject of a later book.

During the late 1970s, I began serious research into the life and music of Blind Lemon Jefferson. My research continued into the 1980s and 1990s but was interrupted by many other demands on my time, including Ph.D. studies in world religions at Baylor University from 1986 to 1995. Nevertheless, during the latter period, I found the time to conduct a number of interviews with people who knew Blind Lemon. These interviews have provided very valuable information for this book.

I am grateful to many individuals and institutions for their help with my research. The staff of the Freestone County Museum, the *Mexia Daily News,* the Dallas Public Library, the Waco–McLennan County Library, and Baylor University's Moody Library and Texas Collection were very helpful during my many visits. I am grateful to the late Uel L. Davis Jr., longtime Wortham postmaster, for sharing with me copies of articles from his file on Blind Lemon. I used Laura Lippman's 1983 interview with Davis, which originally appeared in the *Waco Tribune-Herald* (and which was clipped for me by my mother-in-law), and this article has since been quoted by Alan Govenar in his book *Deep Ellum and Central Track.*

During the fall of 1986, I had the pleasure of meeting Dr. Bill Ferris, then director of the Center for the Study of Southern Culture at the University of Mississippi and now president of the National Endowment for the Humanities. He encouraged my research on Blind Lemon and urged me to submit an article to *Living Blues,* an outstanding magazine published at Ole Miss. As a result, my article "Music Rooted in the Texas Soil" appeared in the November/December 1988 issue. I am grateful to Dr. Ferris and to editor Peter Lee for arranging publication. I also appreciate the encouragement given to me by such noted blues scholars as Alan Govenar, Kip Lornell, and Jeff Todd Titon.

Mr. and Mrs. Mick Knight, two British blues fans, be-

friended me in 1989. In two trips to Freestone County, they took the older pictures included in this book and provided much help with my interviews. During this enjoyable field-work, Mick entertained both interviewer and interviewees with his performance of Lemon's "One Dime Blues" and "See That My Grave Is Kept Clean." Isaac Cary Sr., with whom I have been closely associated in various houses of Prince Hall Freemasonry for nearly twenty years, was very helpful in pro-viding most of the newer photographs. Some were taken in Wortham at the Black Cemetery, the Blind Lemon Jefferson Community Center, and Smith Chapel Primitive Baptist Church. Others were taken in Dallas' Deep Ellum district at Blind Lemon Urban Bar and Bistro. Thank you, Brother Cary.

Two blues guitarists from Waco—George Spratt and Loydell Burks—were also quite helpful. While neither ever met Lemon, they helped put me in touch with people who did.

At the Blind Lemon Jefferson Blues Festival in Wortham on September 8, 2001, I had the pleasure of meeting for the first time the "Blues Preacher," Rev. K. M. Williams. Since then K. M. has helped me to promote this book at the Fairfield Sesquicentennial on October 27, 2001, and within the blues community of Dallas. K. M. was instrumental in arranging a meeting with Don C. Ottensman—better known as "Don O"—the Texas Blues disc jockey at KNON Radio in Dallas. I am grateful to K. M. for hooking us up and to Don O for includ-ing me in the scheduled activities for Texas Blues History Week 2002 in the Dallas–Fort Worth area.

I am grateful to my many interviewees, some living and some dead, who shared with me their recollections of Blind Lemon Jefferson. My most recent interviewee, Cordell Butcher, a Wortham native and long-time resident of West Dallas, not only provided much valuable information but also inspired me with the intriguing question of "What's stopping you from being a writer?"

I am thankful to my wife Debra for all of her love and sup-port. I am also thankful for the encouragement of other fam-ily members, including my mother-in-law, Aldessa Bass, and

her sister, LaVerne Brackens (both of Fairfield). LaVerne truly understands the meaning of the blues. Above all, I thank God for daily giving me the strength to meet this and all challenges of life. I hope that this book will give the reader a greater appreciation not only of Blind Lemon Jefferson but also of the richness and diversity of African American music.

Chapter 1

The Historical Context of the Career of Blind Lemon Jefferson

THE RISE OF THE BLUES

Blind Lemon Jefferson was a blind street musician from Freestone County, Texas, who became a successful Chicago recording artist. Between 1926 and his untimely death in 1929, he was the largest-selling black blues singer in the United States.[1] His music reflected the typical themes of the blues within the context of black American social life in the post-Reconstruction South. He was a Texan whose life and music were deeply rooted in the Central Texas soil. Despite his years in Chicago and his travels in various states, he remained, through it all, a Texas blues singer.[2] One cannot understand Blind Lemon Jefferson without understanding the blues in general and the Texas blues in particular.

The first blues put on record appears to have been Mamie Smith's "Crazy Blues," which appeared in 1920. W. C. Handy (the "Father of the Blues"), Clarence Williams, and Perry

Bradford copyrighted and formally composed blues for the early women singers, including Bessie Smith, Ma Rainey, Clara Smith, and Victoria Spivey. However, none of these individuals can take credit for creating the blues.[3] Handy admitted: "Each of my blues is based on some old Negro song of the South, some old song that is part of the memories of my childhood and my race. I can tell you the exact song I used as the basis for any one of my blues."[4]

The music of Blind Lemon Jefferson was an expression of archaic or country blues. This style, which is regarded as the first phase of the blues as an established form, is characterized by nonstandized forms, unamplified guitar, and spoken introductions and endings. At times, country blues performers were known to use ostinato patterns in the guitar accompaniment, bottlenecks on the frets of the guitar, and rough, growling tones, with the falsetto voice used for contrast or emotional emphasis. This style stands in contrast to the classic or city blues style, which developed during the 1920s and was characterized by standardized form with regular beginnings and endings and two or more instruments in the accompaniment.[5]

In a study of blues as a precursor to soul music, Arnold Shaw wrote:

> Rural in origin, the earliest blues developed in places with limited instrumental resources and without a European instrumental tradition. The voice was used as an instrument. The music was a form of self-expression and self-contemplation, self-amusement, and only later a music for performance and entertainment. It also became a music for dancing, but in its earliest stage, it was the itinerant music of men traveling from farm to farm, lumber camp to lumber camp, town to town, and unquestionably, sweetheart to sweetheart.[6]

Louisiana, Tennessee, and Texas have each been credited with being the place of origin of the blues. Most scholars, however, contend that the most likely birthplace was the Mississippi Delta, which has produced the largest number of

bluesmen. If this is so, then the following statement may be true: "The blues came out of Mississippi, sniffed around in Memphis, and then settled in Chicago where it is most likely it will peacefully live out the rest of its days."[7]

While Chicago has played an important role in the lives of many blues singers, including Blind Lemon Jefferson, there can be no doubt that the blues is basically southern music. There is a measure of truth in the claim that the blues began in 1619, when the first nine Africans arrived at Jamestown, Virginia. The roots of the blues lie in antebellum black music, which included not only the traditional "Negro spirituals" but also work songs, field hollers, ring shouts, and chain gang moans.[8]

Despite pre–Civil War roots, however, the blues is basically post–Civil War music. In his book *Big Road Blues,* David Evans stated that the blues originated during the 1890s, a time marked by the coming to maturity of the first generation of blacks born out of slavery. The attitudes of older southern blacks of this era were a response to slavery, and their songs, in large part, reflected their slave past.[9] The music of younger blacks, in contrast, reflected a very different social situation, as described by Evans:

> Slavery was brutal and oppressive, but it offered the black a well-defined role as an anonymous member of a slave society whose basic physical needs would be taken care of by his master. Post-Reconstruction "freedom," in contrast, offered black people economic independence, individualism, industrial life, and the chance for a greater expression of love and family responsibility. It also, however, left blacks educationally unprepared to cope with this new responsibility and sense of individualism and with the economic competition of industrial life. It offered, as well, racial discrimination, Jim Crow laws, and the Ku Klux Klan, jail, the chain gang, sharecropping, and the life of the itinerant worker. If economic failure, breakup of the family, and a desire to escape through travel resulted from these conditions, it is no wonder that the blues arose at this time.[10]

It appears that the 1890s offered unprecedented opportunity for those blacks who could take advantage of it. For many others, though, it was a period of terrible hardship and frustration. Thus, the blues arose during an era of both opportunity and confusion. Such confusion was also faced by poor whites, but they did not face the added burden of racial discrimination. However, whites who struggled during this time may have developed an appreciation of the blues. In every generation, as people of all races have encountered problems in coping with difficult times, the blues have had an appeal.[11]

SOUTHERN BLACK SOCIAL LIFE AS SETTING FOR THE BLUES

From the Civil War to the Great Depression, the South was dominated by a tenant-farming cotton economy. Sharecroppers, many of whom were black, often could not make enough money to provide their families with adequate food, clothing, and shelter. Unscrupulous landlords often took advantage of their rural tenants.[12] In face of such difficulties, relief was sought. Saturday and Sunday became very important days in the black community of the South. While picnics, suppers, and serenades continued, the Saturday night whiskey dance became an institution as important in the social lives of rural blacks as the Sunday church service. In the development of these two institutions, drifting musicians and circuit-riding preachers played comparable roles.[13]

Despite the fact that early blues drew from the religious music of both African and Western cultures, it was often considered sinful by the church. In many communities, blues singers were charged with being "backsliders." Some church members referred to blues as the "devil's music." Texas blues musician Lil' Son Jackson claimed that it was, in effect, the spiritual power of the blues that made the music "sinful." The statement "I get my music from God" has been attributed to Blind Lemon Jefferson.[14]

It appears that the fact that the blues singer had an expressive role that mirrored the power of the preacher caused the blues to be both embraced and rejected by the black community and the church. Accordingly, blues singers were almost never completely ostracized. They lived on the margins of what was acceptable and derived their livelihood from itinerant work at house parties and dances.[15]

For many church members and blues fans, there was no problem moving from the Saturday night dance to the Sunday morning worship service. Structural and functional similarities facilitated such transition. Thus, according to Jeff Todd Titon:

> As the preacher voiced the ethic of the church community the blues singer expressed the aspirations of the black culture. The ethic, if not the world view, they reinforced were identical. Interpreted as secular ceremony, the Saturday night dance acted out the sexual embrace, while communal eating and drinking symbolized the bonding of the group. Fighting and gambling tested one's luck, measured how one stood at the moment with Fate. Though the world views differed, they preached the same advice: treat people right. Blues song lyrics teased the boundary between religion and magic, where supplication turned to demand, as the mistreated lover, after reciting his bill of indictment, decided whether to beg, bully, or leave—with an ironic parting shot. The large number of singers and listeners who have testified to feeling better after blues performances indicate that the ceremonies were effective, that people were renewed.[16]

In a 1987 interview with Alan Govenar, Osceola Mays of Dallas said:

> I was fourteen or fifteen when I heard those blues records, heard them on my cousin's record player. Ben Williams had one. They played them and I'd hear them. Blind Lemon Jefferson, Bessie Smith. She was a woman's blues singer. She

sang "Back water risin', Comin' in my windows and doors, And my house fell down, I can't live there no more."

I haven't stopped listening to the blues. I still hear them on these programs on television. Well, some of those blues tell things real true.

My grandmother and mother told me, "Don't sing the blues," and I never sang any around. Tradition, I guess, old people thought it was wrong to sing songs that wasn't allowed in the church. And they call them blues, and you don't call the church songs blues. Old people in the old days thought the blues was just terrible, but some truth was in those songs. They said, "That's the devil's work. I don't want to hear you sing those songs." And I couldn't sing them. I grew out where I just didn't. I believed it was the devil's work.

I loved to hear Blind Lemon Jefferson. One song he sang I remember.

"I was standin' on the courthouse square
One day, one dime was all I have.
Everybody get's in hard luck some time.
Say I'm broke and ain't got a dime,
But everybody gets in hard luck some time.
Do you want your friend to be bad like Jesse James?
Take two six-shooters and rob some passenger train?
Oh, one dime was all I had.
One dime was all I had.
The woman I love is five feet from the ground.
She's a tailor made woman.
She ain't no hand-me-down.
One dime was all I had.

Ain't but one thing that give a woman the blues—
When she don't have no bottom on her last pair of shoes.

The blues ain't nothing but a good man feeling bad.
Blues is the worst thing that a good man ever had."[17]

Noble Sissle, in the foreword to Perry Bradford's *Born with the Blues,* wrote: "The world was waiting for the secret ingredient of the blues as played and sung by the American Negro with its healing power for a wounded heart."[18] There can be no doubt that, by the end of World War I, the blues were firmly established as part of the African American musical vocabulary.[19]

THEMES OF THE BLUES

From the very beginning, the blues ran the gamut of human emotions but, above all, reflected the blues singers' environment, their fear of poverty, their desire to migrate, their relations with their fellowmen and with the opposite sex.[20] The blues have never been known simply to state problems in a matter-of-fact way. Instead, they have employed striking imagery which has enabled the listener to have more than one perspective on a problem. By employing contrast, it is possible for a blues singer to opt for a state closer to equilibrium and, thus, to present his audience with a catharsis of extreme emotions.[21] As a result of this catharsis, the blues do not bring about solutions to problems. This seems related to the fact that the problem areas of life dealt with by the blues are basically universal and are always present in one form or another. These problem areas take the shape of temporary ups and downs in the lyrics, with singers often stretching them to extremes in what has been well described as a celebration of life itself.[22]

SIGNIFICANCE OF BLIND SINGERS OF THE BLUES

It is significant to note that a high proportion of the early blues singers were blind. Some writers contend that, due to lack of other employment opportunities, many blind black men became musicians by default. Others contend that blindness is potentially an advantage when dealing in so heavily an oral/aural occupation as blues singing and that blind singers

tend to give a greater personal commitment to blues techniques.[23] At any rate, a large number of blind men have contributed to the blues, and Blind Lemon Jefferson was one of the greatest contributors of all.

BLIND LEMON JEFFERSON'S SONGS
AS A REGIONAL EXPRESSION OF THE BLUES

The music of Blind Lemon Jefferson reflected the typical themes of the blues within the context of black social life in the post-Reconstruction South. However, it must also be remembered that Blind Lemon was a Texan and that his life and music were firmly rooted in the Central Texas soil. Regional studies of the blues have focused primarily on the Mississippi Delta, Texas, and the East Coast. Texas blues has been characterized as having a great deal of "moaning and droning" but as less percussive and with lighter emphasis on individual notes than the Delta blues. The melodies and, at times, the instrumental parts of Texas blues have some common characteristics. However, there are marked contrasts between the works of Blind Lemon Jefferson and other Texas bluesmen, such as Henry Thomas, J. T. Smith, and Smokey Hogg. Some of the variations have been attributed to the rambling lifestyles of many singers, who leave songs and musical ideas wherever they go.[24]

While many regard Texas as primarily a western state, the Texas experience was genuinely southern for the first black Texans who worked the cotton patches and cane fields. Many of these slaves came to Texas from other southern states between 1850 and 1865. No doubt they brought with them a rich musical strain, from which early Texas blues singers freely drew.[25] Even after the end of slavery, Texas blacks still faced poverty and futility. Many of their songs reflected frustrations related to the tenant-farming system. For those who had problems with the law, the prison farms at Sugarland, Brazoria,

and Sandy Point became training grounds for an education in the blues.[26]

In Texas, there was little local growth to compete with the verses and styles of the old slave songs. These songs functioned as a memory of a past handed down from singer to singer, even after the meaning of many of the verses had become lost. When the Texas blues began to take their musical shape, there were still men and women who remembered their first years in Texas and the songs they had sung about these years. Many slaves had come to Texas from northern Alabama.[27] Others had come from Mississippi and had entered Texas through New Orleans and Galveston.[28] No doubt these and other musical styles influenced the development of Texas blues. Regarding this development, Charters wrote:

> The Texas blues style that emerged from the mingling of its earlier forms of play song, work song, and derivative city blues has some of the thin dryness of the Texas country-side, but it also has a coloring and a shading that is distinctively Texan. The songs themselves are filled with the windless concerns of the blues, eroticism and emotional disappointment, complaint at isolation and poverty, while the singing has some of the high, emotionally veiled meanders across the music of Texas like the rivers across the flat earth of the coastal plain, the water only half covering the gravel of the stream bed, dry and still in the summer heat, but the line of thin trees and cracking mud banks a dusty presence on the Texas landscape.[29]

Richard Middleton described the Texas style as notable for its "sense of control and relaxation, as though the tensions of life, though present and considerable, are containable."[30] In *Meeting the Blues,* Alan Govenar discussed the uniqueness of the Texas sound:

> In Texas, blues has developed a unique character that results not only from the introduction of the electric guitar, but

also from the cross-pollination of musical styles—itself a result of the migratory patterns of blacks—as well as the impact of the recording industry and mass media commercialization. Not only is the black population of Texas less concentrated than that of other states in the South, but blues music in Texas also evolved in proximity to other important musical traditions: the rural Anglo, the Cajun and Creole, the Hispanic, and the Eastern and Central European.[31]

The earliest reference to what might be considered blues in Texas was made in 1890 by collector Gates Thomas, who transcribed a song entitled, "Nobody There." Showing a pentatonic tune containing tonic, minor, third, fourth, fifth, and seventh chords, all of which combine in a manner similar to a blues tune. Later, Thomas published other song texts collected from South Texas blacks. Some of these songs contained lyrics heard in other areas of the South. For example, the song "Baby, Take a Look at Me" had been transcribed by Charles Peabody in Mississippi, while "Alabama Bound" and "C. C. Rider" are variations of blues songs performed in New Orleans by Jelly Roll Morton.[32]

Blind Lemon Jefferson was born in 1893 near the small Central Texas town of Wortham and got his start in music by performing at local events. However, he took his big step toward success when he relocated to the big North Texas city of Dallas in 1912. Ninety years later, Dallas maintains its reputation as a leading center for the blues. According to Bobby "Blue" Bland, one of America's most celebrated blues singers: "A lot of people think that the blues is just a southern thing. Just from Mississippi. And they think that all the people who made the blues popular in Chicago are just from Mississippi. Well that's all wrong. You can argue that Texas was one of the first places the blues came from. You start with the old timers like Blind Lemon Jefferson. These are the guys who *invented* the blues."[33] While Bland's statement about invention is highly

exaggerated, his remarks correctly point out the importance of Texas to the blues world.

Life for Texas blacks in the 1920s was far from pleasant, and much of the unpleasantness of black life was reflected in Blind Lemon Jefferson's musical repertoire. We shall now look at his early life in order to explore the factors that made him one of the outstanding musicians of his day.

Central Texas Years

During the late nineteenth century, in the Couchman community outside of Wortham, Freestone County, Texas, Alec Jefferson married a young widow named Classie Banks. Classie had two sons, Clarence and Izakiah, by her first husband. Her marriage to Alec Jefferson produced seven children. Their oldest daughter was named Frances, and their eldest son was named John. Frances and John were followed by four other girls—Martha, Mary, Carrie ("C. B."), and Gussie Mae.[1] On September 24, 1893, their youngest son, Lemon, was born. The 1900 Freestone County census lists the family of "Alex" and "Classy" Jefferson, including a son identified as "Lemmon B. Jefferson."[2]

At the time, Wortham was best known as a stop on the Houston and Central Texas Railroad line. This area was probably visited by Henry "Ragtime Texas" Thomas and Alger "Texas" Alexander, who became popular in various communities for their performance of blues and dance tunes. It is pos-

sible that young Lemon Jefferson heard them play.[3] Local blues guitarists included Jesse Waffer, Doc Castille, and Lorenzo Ross.[4] It is possible that Ross may have taught Lemon something on the guitar.[5]

Around 1907, John Jefferson tried to hang from a slow-moving train but fell under the wheels and was killed. Thus, ten-year-old Lemon, who was either born blind or lost his sight in early childhood, grew up without a brother. His sisters, however, did their best to help him to adapt to the world around him. There is no record of any formal education. At that time, there were few available schools for the blind, and it seems unlikely that Lemon ever learned to read Braille.[6] None of his medical records—if such ever existed—have survived, so no one knows the extent of his visual impairment. Many have assumed that he was totally blind, but older musicians who knew him in the 1920s suggested that he had some vision. In later life, he was photographed in large wire glasses but never was known to wear dark glasses.[7]

There can be no doubt that Blind Lemon was blessed with a natural gift of musical expression. As a teenager, he mastered the guitar. He often went into Wortham, sitting in front of local businesses and playing for people who had come to town to shop. Wortham resident Quince Cox, who was born on August 8, 1905, shined shoes at Jake Lee's Barbershop as a child. He recalled the singer coming to town every Saturday and sitting on a bench beside the barbershop, with his guitar and his tin cup, into which people would drop contributions. On some days, he said, Lemon would remain on the streets of Wortham until 1:00 A.M., then walk back to his home in Couchman without assistance. As he walked, he said, Lemon would sing, "Blind man stood on the road and cried all night." There were no known incidents of him getting lost on the way home. Cox said that, wherever a bunch of people would hang around, there Lemon would play. He recalled Lemon always being clean, wearing nice clothes and shoes. He occasionally saw him smoking cigars.[8] Pearline Monings of Tehuacana, Texas, stated that he knew all the trails and usually traveled by foot.

She said that she never saw Lemon riding with anyone. She also recalled: "He sure could eat!"[9]

Kathryn Ervin Jefferson of Corsicana, Texas, was born in 1919 and grew up in Wortham. She said that her late husband, J. W. Jefferson, was from Wortham and was probably related to Blind Lemon. She described Lemon as a "great songster" who "came up the hard way" and recalled hearing him sing in Wortham Flat, near the old cotton gin. She said she would drop money in his cup as he would sing, "I know the sun's going to shine in my back door some day."[10]

Mattie Barree Dancer of Streetman, Texas, grew up in Wortham and recalled that, during her teens, she was "crazy about Blind Lemon" and would often follow him around as he played the guitar. Her older sister Bessie, she said, once claimed to be in love with Lemon and was known to go fishing with him. Lemon, she said, could always tell when a fish was biting. She remembered hearing him perform at a place called the Castille Shack, where people would dance to his music. One song which she recalled him often singing was "Going to Chicago."[11]

Hobart Carter, who was born on November 18, 1897, grew up with Blind Lemon and lived in the Couchman community for more than one hundred years. He recalled seeing Lemon walk through the woods, down the trails, and over the bridges by himself. He said that, if Lemon did get lost, he would holler and someone would come and assist him. He remembered hearing Lemon sing in Wortham and in the neighboring towns of Streetman and Kirvin. Lemon's family, he said, were active members of Shiloh Primitive Baptist Church in Kirvin. As a child, he said, Lemon attended a number of churches in the area.[12] Cordell Butcher of Dallas, who was born in Freestone County on April 29, 1915, recalled that Lemon's mother had a powerful singing voice and often sang at Shiloh and other churches in the area. She reported that the Jeffersons joined with other black families in experiencing good times at homecomings and other church meetings throughout these rural communities.[13]

During the early days of his career, when he wandered the streets of Wortham, Groesbeck, Marlin, and Kosse, playing his guitar and soliciting contributions with his tin cup, Lemon gained a reputation as a singer of spirituals as well as blues.[14] It must have been this reputation which resulted in him being hired to perform at a picnic sponsored by the General Association of Baptist Churches at Buffalo, Leon County, Texas. A family named Hopkins had driven from their farm at nearby Centerville to attend the Sunday afternoon social. Throughout the day, eight-year-old Sam Hopkins hung around the blind singer until he finally got up enough nerve to try to play along with him. Lemon turned around and shouted, "Boy, you got to play it right." When Sam finally managed to say something and Lemon realized he was a little boy, he laughed and showed him a little on the guitar, letting Sam play behind him.[15] In later years, Sam was known as "Lightnin'" Hopkins and became an accomplished blues performer in his own right.

Before he was twenty, Blind Lemon was singing for picnics and parties at farmhouses near Wortham and in the surrounding area. Before long, he was one of the most popular entertainers in Central Texas.[16] The late Arthur Carter, a Wortham native born December 6, 1908, recalled hearing Lemon perform at a picnic near Wortham. At this picnic, he reported, an argument developed between Lemon and a Holiness preacher who insisted that it was a sin to sing the blues. Lemon waited until the sermon had reached its peak. He then tuned his guitar and started singing the blues. The crowd left the preacher and gathered around Lemon. Thus, Lemon, in effect, won the argument.[17]

The late Walter Yeldell, an old friend of the Jefferson family, once told the late Frank X. Tolbert: "He didn't need no one to steer him around. He was keener of ear than any man and maybe most wild creatures. He would never walk into a wire fence because he said he could hear music in the wires, even on the stillest of days when he drew nigh. You could do a dance. And Blind Lemon would listen to your foot taps, and then he'd do the same dance. That's how he learned, by ear,

to whip a guitar and other music. He never had no lessons. I sure miss Blind Lemon."[18]

Lemon's cousin Alec Jefferson remembered his performances at country suppers near Waxahachie, about thirty miles south of Dallas. He recalled: "Of course, my mother didn't let me go to them country suppers often. They were rough. Men were hustling women and selling bootleg and Lemon was singing for them all night."[19]

Mattie Barree Dancer reported that the country suppers—also called country balls—were always held outdoors, beginning in August and ending when the cold weather began.[20]

Willie Mae Thomas of Fairfield stated that she heard of Lemon performing at Brown's Creek in the Hopewell community near the present site of the Big Brown Power Plant. She recalled that many black families once lived there and a lot of country balls were held there. She said she never enjoyed such events but her sister Billie Banks enjoyed them very much.[21]

R. L. Thomas was born on February 28, 1915, and grew up in the Central Texas farming communities of Fairfield, Mexia, and Trinidad. He stated that his mother, Nettie Barrow, sponsored country balls in the Fairfield area, and he recalled hearing of such at the Freestone County communities of Wortham, Butler, and Post Oak and in the Limestone County communities of Mexia and Green House (between Tehuacana and Coolidge). Most of these, he said, occurred on Saturday nights and were marked by an abundance of food, corn whiskey, shot beer, and homemade wine. Dances included the Black Bottom, the Charleston, the Two-Step, the Round Dance, and the Buck Dance (a dance without a partner, similar to tap dancing). He heard Lemon sing at the suppers and saw him drink a few drinks. However, he said, he never saw Lemon drunk. Whites as well as blacks attended these events, and white as well as black musicians performed at them. When white women came, they usually came with their husbands. When white men came alone, he said, they were known to dance with black women.[22]

Lemon's musical mannerisms have been described:

Blind Lemon's guitar style and singing were distinctive. He made extensive use of single-note runs, often apparently picked with his thumb. He played in a variety of keys and tunings, but favored the key of C for the blues. He held the guitar almost perpendicular to his chest, which some have attributed to his girth. Musicologist David Evans, however, thinks it had to do more with Jefferson's style of playing, noting that the position was favored by two electric guitarists much influenced by Jefferson: T-Bone Walker and Charlie Christian. Also, as Evans points out, Jefferson in his singing, uses not only the flatted third and seventh tones of the chord common to the blues but also flats, the fifth and sometimes even the sixth tones. . . .

In his songs, Blind Lemon identified himself with the experiences of his audience's suffering and hope, economic anxiety and failure, the breakup of the family, and the desire to escape through wandering, love and sex.[23]

Lemon's songs seem to present an ambivalent attitude toward women. On the one hand, he used such expressions as "good gal," "sugar," "baby," "honey," and "high brown." On the other hand, he used such terms as "wild," "dirty mistreaters," and "deceitful." In "Pneumonia Blues," he held women responsible for his illness; in "Deceitful Brownskin Blues," for robbing him; and in "Peach Orchard Mama," for cheating on him.[24]

In "Mosquito Moan," Lemon recounted the displeasures caused by a common insect. In other songs, he spoke of various pests and animals found in Texas farming communities, such as mules, cows, horses, snakes, and rabbits. In addition to conveying a sense of time and place, the animals may also allude to travel, sexuality, and despair.[25]

In such songs as "One Dime Blues," "Broke and Hungry," and "Tin Cup Blues," Lemon commented on the poverty and oppression experienced by African Americans during the early twentieth century. In "Rising High Water Blues," he spoke of the devastating experience of natural disaster. The injustices of

the criminal justice system were vividly depicted in such songs as "Hangman's Blues," "Prison Cell Blues," "'Lectric Chair Blues," "Lockstep Blues," and "Blind Lemon's Penitentiary Blues." There can be no doubt that the songs of various bluesmen regarding prison and the longing for freedom reflected the social conditions of the times and represented some vital themes in the country blues tradition.[26]

Arthur Carter reported that, as Lemon played and sang, he perspired quite heavily. He also recalled that he was always a "joker" who never seemed sad or depressed, in spite of his blindness. In harmony with the theme of many blues songs, he said, Lemon believed in "treating people right."[27]

Blind Lemon Jefferson, in his songs, at times would refer to the geographical area where he first performed. For example, in "Blind Lemon's Penitentiary Blues" he sang:

> Take Fort Worth for your dressing
> And Dallas for your style.
> Take Fort Worth for your dressing
> And Dallas for your style.
> But if you want to go to the state penitentiary,
> Go to Groesbeck for your trial.
>
> I hung around Groesbeck,
> Worked in hard showers of rain.
> I say I hung around Groesbeck,
> Worked in hard showers of rain.
> I never felt the least bit uneasy
> 'Til I caught that penitentiary train.
>
> I used to be a drunkard, rowdy everywhere I go.
> I say I used to be a drunkard, rowdy everywhere I go.
> If I ever get out of this trouble I'm in,
> I won't be rowdy no more . . .[28]

From all indications, Lemon's songs were marked by rare individuality, consisting primarily of original improvisations and

adapted traditional material. Many of his creations, no doubt, were entirely personal, often having direct relevance to the life of their composer. Rarely did he record straight traditional material or use materials associated with another artist.[29]

John Holder, a native of the McLennan County community of Harrison Switch, between Waco and Marlin, recalled hearing Blind Lemon sing in front of Angelina's Bar on Bridge Street, near the present site of the Waco Convention Center.[30] He remembered some women saying: "Poor blind man pickin' blues. He ought to be pickin' church music" and Lemon replying: "You wouldn't give me any more money if I was pickin' church music" as he collected money in his hat.[31] His sister, Clarice Holder Saul, recalled hearing Lemon sing "I Don't Know What I'd Do Without the Lord" and "You Don't Know What It Means To Be Blind."[32] Pearline Monings of Tehuacana remembered hearing him sing spirituals but could not recall any of the titles.[33]

Like so many early blues singers, Blind Lemon appears to have regularly mediated between the religious culture and the blues culture, finding his place in both.[34] The diversity of his performances later would be seen in his appearances at a tent revival in Waco, a medicine show in Mississippi, and a recording studio in Chicago.[35] Tailoring his music to the musical tastes of the various audiences, Blind Lemon spent most of his time in Central Texas until 1912, when he caught a train for Dallas. Thus began a new chapter in his life.[36]

Chapter 3

Dallas Years

In 1900 the black population of Dallas was less than 10,000. The rural exodus which followed World War I sent thousands of young men and women to Dallas, and by 1920, the black population had doubled. Such a shift in population was partly due to the devastation of the cotton crop in Texas and other southern states by the boll weevil, which put many black farmers out of business. Black men arriving in Dallas sought whatever work was available, while black women often found domestic jobs in the homes of wealthy Dallasites. Black singers from various parts of Texas and Louisiana, who came to Dallas via Highway 80, became conspicuous at this time.[1]

Blues singers were especially visible in Deep Ellum, the area of Elm Street north and east of downtown Dallas. At Elm Street and Central Avenue (known also as Central Track), there was a railroad stop, a place where day laborers were picked up and taken to the cotton fields of Collin County and to various jobs in Dallas County. At that time, Central Avenue connected

Elm Street with "freedmen's town," the black neighborhood that arose after the Civil War near the corner of Thomas and Hall streets. Deep Ellum was marked by clusters of pawn-shops, tailors, secondhand clothing stores, shoeshine parlors, cafes, and sporting houses.[2]

In a July 1937 article in a black weekly newspaper called the *Gazette,* J. H. Owens wrote:

> Down on Deep Ellum in Dallas, where Central Avenue emp-ties into Elm Street is where Ethiopia stretches forth her hands. It is the one spot in the city that needs no daylight sav-ings time because there is no bedtime, and working hours have no limits. The only place recorded on earth where business, re-ligion, hoodooism and gambling and stealing go on without friction . . . last Saturday a prophet held the best audience in this "Madison Square Garden" in announcing that Jesus Christ would come to Dallas in person in 1939. At the same time a pickpocket was lifting a week's wages from another guy's pocket, who stood open-mouthed to hear the prophecy.[3]

English blues scholar Paul Oliver described the influence of Dallas blues singers as follows:

> To the renters and 'croppers who had left the farms and bottom land for the city, the voices of Blind Lemon, Rambling Thomas, or Texas Alexander were singing for them, sharing their own experience and predicament. Crowds would cluster round them on Central Track and the coins would clatter—nickels and dimes—in their hats and tin cups. Money was scarce and few Negroes owned property. Small denominations passed hands for home-brewed liquor and as winnings in street-corner crap games, or paid admis-sion for a party. In the "chock-houses," where a crude form of alcohol cost a matter of cents, pianists hit the keys in a rough-and-ready combination of ragtime and blues: "barrel-house," as it was called, after the rudest of joints where bar-rels supported a plank for a bar.[4]

Prominent among the juke joints and barrelhouses found in Deep Ellum and East Dallas were Lincoln Theater, Ma's Place, 400 Club, Silver Slipper, Abe and Pappy Club, the Brown Derby, and White's Road House. At the time, Dallas was the place for the aspiring blues artist to be.[5]

Blind Lemon Jefferson was one of the musicians imported to Dallas during this period of considerable expansion. By this time, he stood approximately five feet eight inches tall and weighed about 180 pounds. Nevertheless, he got around amazingly well. Sam Price, a pianist from Honey Grove, Texas, described him as "a little chunky fella."[6] In a 1986 interview in a Harlem nightclub, Price told Alan Govenar:

> In Deep Ellum there was an alley called "death row" where someone would get killed every Saturday. And there was a stool pigeon for the police and his name was "Yellow Britches." If someone came into town that he didn't know he'd put some chalk on the back of [the stranger's] pants so that the police could identify him and arrest him. The area near Deep Ellum where there were black folks was a community that engulfed maybe five or six blocks on Central Avenue, and extended for about two blocks on Elm Street. Deep Ellum was the crossing point, where they'd come and take you to pick cotton. Blind Lemon Jefferson stood on that corner. Black folks would gather around him. And there was no commingling with the white folks that went about their business on Elm Street. There were Jewish shopkeepers, secondhand clothing stores, pawnshops on the other side of the same block. The railroad tracks ran up Central Avenue and the street was lined with dance halls, Fat Jack's Theater, the Tip Top Club, shoeshine parlors, and beer joints.
>
> Blind Lemon Jefferson would start out from South Dallas about eleven o'clock in the morning and follow the railroad tracks to Deep Ellum, and he'd get to the corner where Central Track crossed Elm about one or two in the afternoon and he'd play guitar and sing until about ten o'clock at night.[7]

Mance Lipscomb, a guitarist from Navasota, Texas, recalled "a big stout fella" and a "big loud songster" with a "tin cup wired on the neck of his guitar."[8]

Lemon soon discovered that performing in Dallas was quite a change from performing at picnics and parties in rural Texas. For one thing, there was more competition in Dallas.[9] The problems related to earning a living in Dallas were well expressed in the following lyrics to "Tin Cup Blues":

> I stood on the corner and almost bust my head.
> I stood on the corner and almost bust my head.
> I couldn't make enough money to buy me a loaf of bread.
>
> My girl's a house maid and she earns a dollar a week.
> My girl's a house maid and she earns a dollar a week.
> I'm so hungry on pay day, I can't hardly speak.
>
> Now gather round one, people, let me tell you true facts,
> Now gather round one, people, let me tell you true facts,
> That tough luck has struck me and the rats is sleepin' in
> my hat.[10]

For a brief period, Lemon turned to wrestling to help make ends meet. It appears that the novelty of a blind wrestler attracted quite a few people to the arena.[11]

In the intense musical atmosphere of the Dallas black community, Blind Lemon Jefferson influenced other singers and was, in turn, influenced by them. In his singing, he expressed all of the loneliness and poverty of the dry, empty fields of Central Texas, where he had his roots. On the streets of Dallas, his blues training was made complete.[12]

When money was slow in Dallas, Lemon traveled to Houston, where he would perform on West Dallas Street, in the "hoosh pads," speakeasies, and bawdy houses.[13] He also performed at various small towns around Texas. A preacher from Hearne, Texas, remembered seeing Lemon on the streets

during the cotton-picking season, a crowd around him while he sat on a stool, singing.[14]

One of the singers with whom Blind Lemon made contact during his Dallas years was Huddie Ledbetter, also known as "Leadbelly." Leadbelly recalled guiding Lemon through Deep Ellum and down Central Track: "He was a blind man and I used to lead him around. When him and I go in Depot we's sit down and talk to one another."[15] Leadbelly would often do a soft-shoe tap dance while Lemon played a guitar instrumental such as the ragtime-styled "Hot Dog" and a version of "Dallas Rag."[16]

Lemon and Leadbelly frequently performed at the Big Four Club near the railroad terminal. Leadbelly said: "De women's would come runnin! Lawd have mercy! They'd hug and kiss us so we could hardly play." When he declared "him and me was buddies," he implied a relationship of close friendship rather than that of a blind singer and a "lead boy." At the Big Four, Leadbelly would often play mandolin or "windjammer" (accordion) while Lemon would play his guitar and sing. Much of their time was spent on the barrelhouse circuit, wandering from saloon to gin mill, singing for food and drink and for the coins of the patrons.[17] The presence of war clouds on the horizon was evident when the pair sang a parody of "The Darktown Strutter's Ball" called "I'll Be Down on the Last Bread Wagon" and their very popular song "The Titanic." Especially relevant in Dallas were songs about the boll weevil. Both men would eventually record versions of songs about the destructive insect.[18]

The two singers rode the Interurban, the electric railroad that ran from Dallas north to McKinney and south through Corsicana to Waco. Leadbelly recalled: "I'd get Blind Lemon right on. We get out two guitars; we just ride . . . anything. We wouldn't have to pay no money in them times. We got on the train, the driver takes us anywhere we want to go. Well, we just get on and the conductor say, 'Boys, sit down. You goin' to play music?' We tell him, 'Yes.'"[19] Wherever they traveled, they performed at places where a lot of women would congregate. Leadbelly recalled their performance in the rough haunt

of Silver City: "There's a lot of pretty girls out there, and that's what we were looking for. We like for women to be aroun' cause when women's aroun' that bring mens and that bring money. Cause when you get out there, the women get to drinkin' . . . that thing fall over them, and that makes us feel good and we tear those guitars all to pieces."[20] In "Silver City Bound," Leadbelly sang about his travels with Lemon:

> Me and Blind Lemon, goin' to ride on down,
> Catch me by the hand—oh baby—
> Blind Lemon was a blind man,
> He'd holler—"Catch me by the hand"—oh baby,
> "And lead me all through the land."[21]

Other details of the two singers' travels have been documented:

> For a time . . . the pair managed to make a decent living, running a route that included many of the saloons, dance halls, and whorehouses of east Dallas and as far out as Kaufman County. Sometimes their weekend take was as much as $150 and their travels would take them as far as the rough-and-tumble oil town of Groesbeck, some seventy miles south of Dallas on the H&TC Railroad. Blind Lemon attracted special attention by playing what was then called "Hawaiian guitar," a type of open guitar tuning with which he usually used a bottleneck, knife, or short metal cylinder to slide along the strings.[22]

In later years, Leadbelly singled out Lemon over and over again as his great teacher, acknowledging him by name or through his songs. Leadbelly viewed Lemon as a "master musician who lived, ate, and slept the blues."[23] Nevertheless, it is also possible that "Huddie was the senior partner, and probably had more musical experience and a more diverse repertoire than Lemon." In all probability, the two musicians learned a great deal from each other.[24]

Leadbelly eventually recorded for the Library of Congress "Blind Lemon Blues," a narrative blues which he learned from Lemon and named after his friend. This song is about a seventy-five-year-old man who decides to leave home. It describes a dream of this man's return experienced by his wife three years after his departure. She awakens and hears him at the door, asking for forgiveness. She finally gives in, despite her promise to her pastor not to take him back. At the end of the story, the rambler comes in and his children each play a tune on the piano for him.[25]

After Leadbelly was incarcerated in 1917, Blind Lemon employed other guides, including blues singer Josh White. According to White, Blind Lemon would get up late in the day and, around noon, when the crowds were thickest, would take up his stand on a particularly busy intersection and commence to holler from the street corner. While Lemon sang and played his guitar, White accompanied him on the tambourine, tapping in rhythm until a large crowd had gathered. He then turned the tambourine into a collection plate, saying, "Help the blind, help the blind." The duet would often earn $150 during a weekend.[26] James Thibodeaux, a Dallas photographer and painter, remembered seeing these two singers walking together on Thomas Avenue in North Dallas.[27]

Aaron "T-Bone" Walker—another guide—recalled: "Blind Lemon had a cup on his guitar and everybody knew him, you know, and so he used to come through on Central Avenue, singing and playing his guitar. And I'd lead him and they'd put money in his cup. . . . My whole family was crazy about him. He'd come over every Sunday and sit with us and play his guitar, and they sang and they had a few drinks."[28] In another interview, Walker stated: "Lemon sang things he wrote himself about life—good times and bad. Mostly bad, I guess. Everyone knew what he was singing about. There's nothing *new* in the blues. It's everything that's going on. You've heard it all before, maybe a whole lot of times. . . . One thing in particular is the root of the songs most fellows sing: women and women's ways. When you start messin' with that, you may be singing all night and still not get enough."[29]

Accounts of Blind Lemon's ability to get around tend to be contradictory. While a number of musicians claimed to have led him through the streets, others were astounded by his sense of direction. Sam "Lightnin'" Hopkins claimed: "He didn't allow no one to lead him. He say then you call him blind. No, don't call him blind. He never did feel like that. He was born like that."[30] Lemon's sister was quite impressed when she would visit him in Dallas and he would show off how well he could get around unaided.[31] The following explanation seems plausible enough: "Perhaps Blind Lemon used a lead boy at some times—particularly when he was in unfamiliar surroundings—and not at others. Some of those who claim to have led him may be embellishing their own stories. Or perhaps the stories are true, and Blind Lemon simply liked the company or enjoyed serving as a mentor to young musicians."[32]

A number of people have recalled seeing Lemon put his hat, rather than a tin cup, down in the street, seeking contributions. There are several reports regarding his ability to identify the money given to him. Singer Victoria Spivey heard him often say, "Don't play me cheap," and she insisted that he was serious about this.[33] According to bluesman Tom Shaw: "You could hand him a dozen bills. He'd tell you just that fast whether it's a five- or a one-dollar bill."[34]

The late blues pianist "Whistling Alex" Moore, who was born in Dallas on November 22, 1899, knew Blind Lemon when they were both performing in North Dallas. He recalled that, at night, he would often see Lemon performing on Thomas and Hall streets. They never performed together, as both were solo artists. He did not recall ever seeing anyone perform with Lemon, whom he remembered as a very likable person. He remembered Lemon on the streets playing his "starvation box" (a slang expression for the guitar) and stated that people would often joke about the fact that, every time Lemon came to North Dallas, "he had a chicken" (i.e., he had someone cooking for him). At the time, Moore said, the area of Thomas and Hall streets was called "the Strip."[35]

The 1920 census shows Lemon living in Freestone County with his older half-brother, Nit C. Banks, and Banks' family. Lemon's occupation is listed as "musician" and his employer as "general public." He apparently made many trips between his official place of residence and the big city of Dallas, where he found most of his work.[36] According to Charlie Hurd, who was 101 years old and living in a Mexia, Texas, nursing home in 1993, Lemon also played in a string band with the Phillips brothers: Wash, Tim, and Doc.[37]

According to Paul Oliver, in spite of his blindness, Lemon was an avid gambler, relying on the witnesses around him to ensure that he was not swindled by a crooked dealer. Reportedly, he was better able to defend himself than most blind people and perhaps many sighted people, as well. Josh White recalled Lemon spending several hours in heavy drinking and then returning to his home, lying down with his guitar, and shouting his blues into the night.[38] Pianist Sam Price reported that Lemon, upon returning home, would shake his liquor bottle and, in this manner, could tell if any was missing. According to Price, if any liquor was gone, Lemon would thrash his wife.[39]

Reportedly, around 1927, Lemon married a woman named Roberta Ransom, who was ten years his senior. It was in 1927 that Theaul Howard, her son by a previous marriage, died.[40] According to some reports, Lemon and Roberta also had a son.[41] Several long-time residents of Mexia recalled that the couple lived in a house on West Hopkins Street and that he performed on "the Beat," a nearby strip of black businesses that included a movie theater, cafes, and honky-tonks.[42]

Whether Lemon actually abused his wife, as Price claimed, it appears quite probable that Lemon's chaotic lifestyle eventually resulted in marital separation. According to some reports, she came to Couchman a few times and stayed with his parents, but usually did not know his whereabouts. Neighbors of the Jeffersons remembered her as a quiet, laid-back woman.[43]

Once Lemon had obtained success as a musician, he began buying clothes at the Model Tailors, a Deep Ellum business

owned by a Jewish family named Goldstein. For many Dallasites, black and white, the patronage of this firm became a status symbol. According to Isaac Goldstein, "They had to have . . . good slides . . . a good hat and a Model Tailors suit."[44]

During the 1920s, Paul Quinn College professor Vivian Hillburn lived in Cedar Top, the black community of Kilgore, an oil-boom town in East Texas. She recalled a number of black beer joints whose owners were from older oil fields in Arkansas and Louisiana. On Saturday nights, she said, people came to town to dance to the jukeboxes after selling cotton and pulpwood. She remembered hearing Blind Lemon sing "Loveless Love" and observed that he carried his guitar like an organ grinder. When people in the audience would request certain songs, he would say, "Just wait a while. Hold your cool." She said that people would bring him some fried chicken or buy him a bowl of chili. She stated that he would stay in cheap motels called flophouses, where women would hustle him. It seems that Lemon would usually stop at Cedar Top when traveling between Dallas and Shreveport. She also recalled him performing for Juneteenth celebrations and at rodeos at the local Hillburn Ranch.[45]

Sam Price, who had studied music under the daughter of Booker T. Washington, reported during a 1979 interview in a Greenwich Village nightclub: "Blind Lemon was using the term 'booger rooger' and playing the boogie-woogie rhythm as far back as, oh, 1917–18, when I heard him in Waco. A little later, in Dallas, he used to spend every day walking from one end of town to the other, playing and singing on the street and in various taverns for tips."[46] During the mid-1920s, Price was employed as a record salesman in R. T. Ashford's store in Dallas. He wrote to Mayo Williams, a black talent scout for Paramount Records in Chicago, enclosing a copy of a test recording of Lemon's singing. This recording was done by means of a portable machine set up in the rug department of a local furniture store sometime in the spring of 1925.[47] In May of that year, Lemon recorded for Paramount "Old

Rounder's Blues" and "Begging Back." By the end of 1925, he was settled in Chicago. Williams had brought him to the "windy city" after receiving approval of Paramount's directors.[48] Ashford accompanied Lemon on his first trip to Chicago.[49] Thus began the final stage of the career of Blind Lemon Jefferson.

Chapter 4

Chicago Years

Blind Lemon Jefferson arrived in Chicago in late 1925 or early 1926. He has been described as the first "downhome blues singer to enjoy commercial success."[1] He became the model for record companies when they sent portable field equipment to southern cities or invited southern singers to their home studios in the North. His model was quite a contrast to the vaudeville sophistication of the blues singing queens, such as Bessie Smith, who generally relied on professional songwriters and accompaniment by pianos and jazz bands. He sang from memory and, on the majority of his records, accompanied himself on the guitar. He never adopted the vaudeville framework device of the sung, explanatory introduction to let the listener know why he was blue, although he did on one or two occasions begin a song with a spoken introduction.[2] He has been called "the first truly great male blues singer to record" and "the most popular, influential and widely-known before the Leroy Carr–Big Bill Broonzy era."[3]

Upon arrival in Chicago, Blind Lemon became quite popular in the black community. He was often seen on street corners, in nightclubs, and at various private and semi-private socials, including house-rent parties on the South Side.[4] His usual place of residence was in the latter section of Chicago in a kitchenette located at Thirty-seventh and Rhodes.[5]

In 1925, when Lemon was hired by Paramount Records, this company had a reputation as "an odd, minor league record company" that was a subsidiary of a Wisconsin chair company. Paramount 78s were not recorded very well, suffered from poor pressings, and lacked a comprehensive national distribution network. Nevertheless, Paramount was ahead of its larger competitors in marketing down-home country blues, a type of music whose popularity was rising.[6]

It is highly probable that some of Blind Lemon's earliest records were not blues but, rather, spirituals. In December 1925 or January 1926, under the pseudonym Deacon L. J. Bates, he released "I Want to Be Like Jesus in My Heart" and "All I Want Is That Pure Religion," on Paramount (Pm) 12386. These works have been described as "completely 'straight' performances of well-known Gospel songs" in which "Jefferson's vocal and instrumental idiosyncracies can be detected on close listening."[7]

In March 1926 the following records were released: "Got the Blues"/"Long Lonesome Blues" (Pm 12354) and "Booster Blues"/"Dry Southern Blues" (Pm 12347). In April 1926 he recorded "Black Horse Blues"/"Corinna Blues" (Pm 12367). One month later, he repeated "Got the Blues"/"Long Lonesome Blues" and recorded two versions of "Jack O'Diamond Blues"/"Chock House Blues" (Pm 12373). His recordings resumed in August, when "Begging Back" and "Old Rounders Blues" (Pm 12394) were again released. The month of November was busier than any previous month. At this time, he released the following records: "Stocking Feet Blues"/"That Black Snake Moan" (Pm 12407), "Wartime Blues" (Pm 124025), "Broke and Hungry" (Pm 12443), and "Shuckin' Sugar Blues" (Pm 12454). In December he com-

pleted his 1926 recordings with the following numbers: "Booger Rooger Blues" (Pm 124025), "Rabbit Foot Blues" (Pm 12454), and "Bad Luck Blues" (Pm 12443).[8]

Blind Lemon Jefferson's early Chicago work has been described by Paul Oliver as the beginning of "a remarkable series of recordings which preserve the blues in its folk form at the point of transition from the field holler to the street corner and the barroom floor."[9]

According to some sources, Lemon's manager, Mayo Williams, was so appreciative of Blind Lemon's earning power that he bought him a $725 Ford and the singer could afford to hire a chauffeur to drive it for him. Lemon is also reported to have owned a 1923 or '24 Dodge, often mentioned in his performances. Also, at the encouragement of Williams, he put a substantial amount of his royalties in savings, with his account balance reaching $1,500.[10] Other sources insist that Lemon earned little money from his recordings for Paramount. By 1927, according to Samuel Charters, he was "a dirty, dissolute man, interested in very little besides women and liquor." Charters reported that Williams, at the end of each recording session, would bring him a few dollars, a bottle of cheap whiskey, and a prostitute. When Williams left Paramount in 1927, the company's relations with Lemon were strained. A young lady named Althea Robinson was assigned to work with him, but their relationship appears not to have been the best.[11]

It appears that Blind Lemon returned to Dallas at intervals during his Chicago years. It was probably during one such visit to his "old stomping ground" that he met Polk C. Brockman of Okeh Records.[12] In March 1927 Brockman and his colleague from Okeh, Tom Rockwell, escorted Lemon to the Dallas depot for a trip to Atlanta, Georgia. Brockman made an appointment for the recording session, then caught another train to Atlanta. When Lemon arrived very late, he told Brockman he had gotten off at Shreveport, because he had never been there and "wanted to see the town." Brockman observed, "He got around remarkably well for a blind man."[13] Paramount did not

take kindly to Lemon recording for a competitor. Probably as a result of protests from Paramount, Okeh issued only two of Blind Lemon's songs.[14] These songs, which were released on OK-8455, were "Match Box Blues" and "That Black Snake Moan."[15]

The latter Okeh recording was one of Blind Lemon's most famous songs and is quite representative of the "double meanings" of his lyrics. This song was influenced by an earlier recording called "Black Snake Blues" by Victoria Spivey. This blues queen had met Lemon years earlier at a house party in Galveston, Texas. They performed together at a number of parties and picnics in Texas before either ever recorded.[16] She later recalled:

> Lemon and myself continued meeting at house parties where we would give one another much-needed intermissions. What a pleasure! It got so good that the landladies would try to hire both of us at the same time. We did it when we could and loved it. . . . The more money the house lady made the more we made—although we never worked the joints under ten dollars per night . . . Plus stacks of those Bo dollars [silver dollars] which people would lay as tips across the piano board, plus all you could fool the public that you could drink.[17]

In March 1926 Spivey recorded "Black Snake Blues" for Okeh in Saint Louis, Missouri. She always contended that the song described what happened to a girlfriend when a black Texas field snake crawled into the cabin where she was living, with absolutely no sexual overtones. However, she complained, Blind Lemon "changed it into a sex song."[18] In Blind Lemon's "Moan," the black snake became a phallic symbol. This song includes the following words:

> Hey: ain't got no mama now
> She told me late last night: you don't
> need no mama nohow.

Mmm: black snake crawling in my room
And some pretty mama: had better
 come and get this black snake soon.
Oh that must have been a bedbug:
You know a chinch can't bite that hard.
Asked my baby for fifty cents:
 she said Lemon ain't a dime in the yard.
Mama that's all right: most any old way you do.
Mmm what's the matter now
Tell me what's the matter now
Tell me what's the matter baby: I
 don't like no black snake nohow.
Well wonder where that black snake gone.
Lord that black snake mama: done
 run my darling home.[19]

When she first heard "Black Snake Moan," Spivey charged Lemon with stealing her lyrics. She stated: "We were buddies . . . until I heard his recording of "Black Snake Moan" on Paramount which came out some months after my original "Black Snake Blues" on Okeh. I was really angry for a while knowing that Lemon and myself were like brother and sister in our jobs."[20] However, they were later reunited in Saint Louis and he reminded her that, at a Texas house party, she had once given him permission "to use those snakes." They had a good laugh and renewed their friendship.[21]

Blind Lemon did the following additional recordings for Okeh: "My Easy Rider," "Elder Green's in Town," "English Stop Time," and "Laboring Man Away from Home." However, these records were never issued.[22]

It appears that, during his years of recording, Lemon traveled extensively.[23] He may have made sporadic visits to the farm at Couchman, but it appears that his family saw little of him after he began working in Chicago.[24] His meeting with Victoria Spivey, as previously mentioned, occurred in Saint Louis. There and also in Memphis, Tennessee (both flourishing recording centers), Lemon reportedly played for house par-

ties and drew crowds at local barbershops.[25] Tennessee blues-man Sleepy John Estes recalled hearing Lemon sing "Diving Duck Blues" on Front Street in Memphis.[26] He was known to travel with the cotton harvest, making stops in Louisiana, Oklahoma, Mississippi, and Alabama, performing at country picnics and in beer joints in small towns and cities.[27] It appears that hardly any blues-conscious area missed a visit from him. The lyrics to his songs contain numerous references to his travels.[28]

Blues singer-turned-preacher Rubin Lacy reported meeting Lemon for the first time in Chicago and said that the blind singer accepted his invitation to visit him at his home in Itta Bena, Mississippi. At the time, Lacy was hailed as the best blues performer in the West. They gave joint concerts in nearby Moorhead and Greenwood. Lacy is the source of the popular story that, on a Sunday during their time together in Mississippi, Lemon refused the offer of twenty dollars to perform a blues song, saying, "I couldn't play it. My mother always taught me not to play on Sunday for nobody. Today is Sunday." Lacy, who had not yet accepted his call to the ministry, said, "I'll play it. I might as well play it on a Sunday as play it on a Monday." He played the requested song and received the twenty dollars.[29]

Another Mississippi bluesman, Houston Stackhouse, remembered seeing Lemon in his hometown: "He came to Crystal Springs and was playin' in some little show for a doctor. . . . They had it in Freetown, there at the colored school. There was plenty of people there. It was a big school and crowded all indoors, people couldn't get to see him. They had to bring him out to the front, on the porch."[30]

In Mississippi and other states, Lemon encountered countless musicians, many of whom were influenced and inspired by him. Many adopted his songs, and a few directly copied his style, including Isaiah Nettles, better known as the "Mississippi Moaner."[31] Verses from "Long Lonesome Blues" reappared in Nettles' "It's Cold in China Blues," and similar verses appear in the Mississippi Sheiks' "Winter Time Blues,"

Shorty Bob Parker's "So Cold in China Blues," and Smoky Harrison's "Iggly Oggly Blues."[32]

A visit to Alabama was recalled twenty-five years later by a singer named Horace Spratt, who said that, at the time, Lemon's guide was named Richard Shaw. Another Alabaman, "Red" Willie Smith, told folklorist Harold Courlander that he had played in Blind Lemon Jefferson's "traveling folk band."[33] Walt Davis, a member of Clarence Ashley's Blue Ridge hillbilly band, claimed to have once seen Blind Lemon in North Carolina. Hobart Smith, a white musician, reported learning some of Lemon's songs when Lemon performed in Saltville, Virginia.[34]

Blind Lemon returned to his original company in April 1927, recording "Easy Rider Blues" (Pm 1272). In May and June he recorded four songs to the piano accompaniment of George Perkins: "Rising High Water Blues" (Pm 12487), "Weary Dog Blues" (Pm 12493), "Right of Way Blues" (Pm 12510), and "Teddy Bear Blues" (Pm 12487). Perkins may have written the former two, but it is almost certain that the latter two were Blind Lemon's original compositions.[35] On one occasion, Lemon reportedly shouted at Perkins, "Whip that piano, Mister piano whipper!" According to Charters, this was probably Lemon's way of giving a vague compliment. Other June recordings include "Black Snake Dream Blues" (Pm 12510), "Hot Dogs" (Pm 12493), and, under the pseudonym of Deacon L. J. Bates, the spiritual "He Arose from the Dead" (Pm 12585).[36] At this time, "He Arose" was over one hundred years old and had been published a number of times, with the best-known recording done in 1872 by the Jubilee Singers of Fisk University in Nashville, Tennessee.[37]

In September 1927 Lemon recorded "Struck Snow Blues"/ "Rambler Blues" (Pm 12541). October was a very productive month, as indicated by the following recordings: "Chinch Bug Blues"/"Deceitful Brownskin Blues" (Pm 12551), "Sunshine Special"[38]/"Lonesome House Blues" (Pm 12578), and "Where Shall I Be?"/"See That My Grave's Kept Clean" (Pm 12585).[39] "Where Shall I Be (When the First Trumpet Sounds)?" is another traditional spiritual, a version of which was transcribed

in Howard B. Odum and James Weldon Johnson's book *The Negro and His Songs,* which was published by the University of South Carolina Press in 1925.[40]

During the 1920s, there was practically no blues radio programming to compete with record sales. The number of blues and gospel titles released each year grew from about 50 in 1921, to 250 in 1925, and 500 in 1927. Sales were phenomenal. It has been estimated that in 1925 and 1927, blacks were buying 10 million records, a number approximately equal to the black population counted by census takers. In view of the fact that the other mass media—radio, motion pictures, and newspapers—were not at that time trying to appeal to black cultural values, the impact of these "race records" must have been overwhelming.[41]

About this time, the *Paramount Book of Blues* was released. This included the following advertisement of Blind Lemon's songs: "To realize that the beautiful things one hears about—one will never see? Such was the heart-rending fate of Lemon Jefferson. . . . Then—environment began to play its important part in his destiny. He could hear and he heard the sad-hearted, weary people of his homeland, Dallas—singing weird, sad melodies at their work and play, and unconsciously he began to imitate them—lamenting his fate in song."[42] An advertisement in the *Chicago Defender* described one of his records as "a real old-fashioned blues by a real old-fashioned blues singer" who "plays the guitar in real southern style."[43]

Advertisements of Blind Lemon and other blues singers employed the following technique:

> The lyrics and titles of downhome blues songs enabled the illustrators to place the plantation stereotype more firmly in the drawings. As for the city black, he was invited by the jive talk, to laugh at his country cousin. The dignity of the singer customarily was preserved in a photo which separated him from the "I" in the song, while the reader and prospective listener was supposed to laugh at the predicament of the character whose troubles he sang about.[44]

Such advertisements were supplemented by the aggressive mail-order business of Fred Boerner, who was employed by Paramount to distribute various items to southern customers. In December 1927 Boerner promoted the aforementioned collection of country blues called the *Paramount Book of the Blues*.[45] Advertisements were placed in northern black newspapers with large southern circulations. Sales were made through local retailers, including music and furniture stores, tobacco shops, newsstands, barbershops, and drug stores.[46]

Blind Lemon Jefferson made no records from October 1927 until February 1928. This long period of inactivity, coupled with the fact that a number of his 1928 records have prison themes, leads some scholars, including Paul Oliver, to suspect that Blind Lemon might have spent some time in jail.[47] In February 1928 he made the following recordings: "Blind Lemon's Penitentiary Blues" (Pm 12666), " 'Lectric Chair Blues"/"See that My Grave Is Kept Clean" (Pm 12608), "Mean Jumper Blues"/"Balky Mule Blues" (Pm 12631), "Change My Luck Blues" (Pm 12639), and "Prison Cell Blues"/"Lemon's Worried Blues" (Pm 12622).[48] Whether Blind Lemon spent time in jail, he certainly sought to empathize with the plight of the prisoner. This is well reflected in some of his lyrics.[49] For example, in "Prison Cell Blues," he says:

Getting tired of sleeping: in this lowdown lonesome cell
Lord I wouldn't've been here: if it hadn't've been for Nell.
Lay awake at night and just can't eat a bite.

Used to be my rider: but she just won't treat me right.

Got a red-eyed captain: and a squabbling boss
Got a mad dog sergeant: honey and he won't knock off.

I asked the government: to knock some days off my time
Well the way I'm treated: I'm about to lose my mind.
I wrote to the governor: please turn me a-loose
Since I didn't get no answer: I know it ain't no use.

I hate to turn over: and find my rider gone.
Walked across my floor: Lordy how I moan
Lord I wouldn't't've been here: if it hadn't't've been for Nell.
I'm getting tired of sleeping: in this lowdown lonesome cell.[50]

Blind Lemon's "'Lectric Chair Blues" is even more illustrative of empathy. While there is no evidence that either Lemon himself or anyone close to him was ever on death row, the song's intent is clear. Thus, Lemon could sing:

I want to shake hands with my partner
 and ask him how come he's here.
I want to shake hands with my partner
 and ask him how come he's here.
I had a mess with my family
 they goin' to send me to the electric chair.

I wonder why they electrocute a man after
 the one o'clock hour of the night.
I wonder why they electrocute a man after
 the one o'clock hour of the night.
Because the current is much stronger
 then the folkses turn out all the lights.

I sat in my electrocutin' room
 my arms folded up and crying.
I sat in the electrocutin' room
 my arms folded up and crying.
But my baby had to question
 whether they gonna electrocute that man of mine.

Well they put me in a coffin
 to take me all the way from here.
Well they put me in a coffin
 to take me all the way from here.
I'd rather be in some new world
 than to be married in the 'lectric chair.

I seen wrecks on the ocean
 I seen wrecks on the blue sea
But my wreck that wrecked my heart
 when they brought my electrocuted daddy to me.[51]

In his book *Early Downhome Blues,* Titon well expressed the uniqueness of "'Lectric Chair Blues" when he wrote: "There are few downhome blues stanzas more grim than the one explaining that the 1:00 A.M. death hour is chosen because more current is available after people have gone to bed."[52]

In March 1928 Blind Lemon recorded his famous "Piney Woods Money Mama," and, on the flip side, "Low Down Mojo Blues" (Pm 12650). Other March records include "Lemon's Cannon Ball Blues" (Pm 12639) and "Long Lastin' Lovin'" (Pm 12666). "Low Down Mojo Blues" was recorded again and issued three months later as Pm 12650. The latter was the only Blind Lemon Jefferson record released in June. However, the following month was marked by the release of the following records: "Competition Bed Blues"/"Sad News Blues" (Pm 12728), "How Long How Long" (Pm 12685), and "Lock Step Blues"/"Hangman's Blues" (Pm 12679).[53] The latter two songs, both of which were reissued the following month, have prison themes.

On August 4, 1928, the *Chicago Defender* carried an advertisement for "Blind Lemon's Birthday Record," which featured "Piney Woods Money Mama" and "Low Down Mojo Blues." Blind Lemon's picture, along with a birthday streamer, appeared on the label. However, record sales were very low.[54]

In addition to the birthday record, August 1928 saw the recording of "Maltese Cat Blues"/"DB Blues" (Pm 12712) and "Christmas Eve Blues"/"Happy New Year Blues" (Pm 12692).[55] It appears that the latter two songs were released and advertised in time for dealers to order for the festive season. The record was described as a "rip-snorting hit," and dealers were told it "Should Be in Your Stocks Now," in order to avoid the Christmas rush.[56] On "Christmas Eve Blues," Blind Lemon sang:

Just the day before Christmas
Let me bring your present tonight.
I wanna be your Santa Claus
Even if my whiskers ain't white.[57]

Blind Lemon made no other records in 1928. He resumed recording in January 1929, with the release of the following: "Eagle Eyed Mama"/"Dynamite Blues" (Pm 12739), "Disgusted Blues" (Pm 12933), and "Competition Bed Blues" (Pm 12728). Two months later, his records were as follows: "Oil Well Blues"/"Saturday Night Spender Blues" (Pm 12771), "Tin Cup Blues"/"That Black Snake Moan No. 2" (Pm 127560), "Empty House Blues" (Pm 12946), and "Big Night Blues" (Pm 12801).[58]

Blind Lemon made no other records for four months. It seems quite likely that it was during this time that he made his last visit to Wortham. Riding in a big car, complete with a chauffeur, Lemon took a lot of local women riding, reveling in his musical success.[59]

In August 1929 "Big Night Blues" was reissued on the back of his better known "Peach Orchard Mama." The latter song presents another example of lyrics with double meanings. Obvious sexual overtones are found in these verses:

Peach orchard mama: you swore nobody'd
 pick your fruit but me.
I found three kid-men: shaking down your
 peaches tree.
One man bought your groceries: another joker
 paid your rent.

While I work in your orchard: and giving
 you every cent.

Went to the police station: begged the
 police to put me in jail.
I didn't want to kill you mama: but I

hate to see your peaches tree fail.

Peach orchard mama: don't treat your
 papa so mean.
Chase out all those kid-men: and let me
 keep your orchard clean.

Peach orchard mama: don't turn your
 papa down
Because when I gets mad: I acts just
 like a clown.[60]

Blind Lemon's final month of recording was September 1929, when the following songs were issued: "Bed Spring Blues"/"Yo Yo Blues" (Pm 12872), "Mosquito Moan"/"Southern Woman Blues" (Pm 12899), "Barbershop Blues"/"Long Distance Moan" (Pm 12852), "Pneumonia Blues"/"That Crawlin' Baby Blues" (Pm 12880), "Fence Breakin' Yellin' Blues"/"Cat Moan Blues" (Pm 12921), "The Cheaters Spell" (Pm 12933), and "Bootin' Me Bout" (Pm 12946).[61]

During his Chicago years, Blind Lemon recorded over a hundred titles, mainly for Paramount. Many of these records were not only best-sellers in their time, they were also featured in display ads in the *Chicago Defender* and other major northern newspapers. Eventually, they developed into blues standards, reissued and copied by later generations of bluesmen and folk singers. Due his great recording success, Lemon became known as the "King of the Country Blues," and he was instrumental in opening the door for the commercialization of this music.[62]

Sadly, by 1929, interest in Blind Lemon's music had begun to decline. His instrumental arrangements became more derivative of his earlier work and he no longer brought his old enthusiasm to recording sessions. Some have argued that he experienced a decline in his vocal range, while others think he was running out of material. Still others insist that, by this time, his lifestyle of heavy drinking and womanizing was be-

ginning to take its toll. The Roaring Twenties were rapidly drawing to a close. On Black Thursday—October 24, 1929—the stock market crashed and America was plunged into the Great Depression, an economic disaster that proved devastating to the recording industry.[63]

On December 28, 1929, the *Defender* carried a small advertisement of Blind Lemon's music. On February 22, 1930, the same newspaper advertised Paramount's "Hometown Skiffle," saying that Lemon had recorded the number along with some other blues singers. This, however, was in error. By February 1930, Blind Lemon Jefferson was dead.[64]

Death of
Blind Lemon Jefferson

Blind Lemon Jefferson's life and career came to an abrupt end in December 1929. Details regarding his death are uncertain, although most accounts agree that he died on the streets of Chicago.[1] At that time, he was still employed by Paramount and singing at a lot of parties on the South Side of Chicago.[2] According to reports from Paramount staff received by John Steiner, the Chicago jazz historian who bought the Paramount property in the 1940s, Lemon left the studios late in the afternoon to play for a house party and was found dead on the street early the next morning, with snow drifting over his body. According to Althea Robinson, Lemon had recorded the afternoon before his death. However, as there was no record issued that month, it is more likely that he was at the Paramount offices on business.[3]

There was a suggestion that he had a heart attack while waiting for his driver to pick him up. The source of this story was Arthur Laibly, who succeeded Mayo Williams as Lemon's

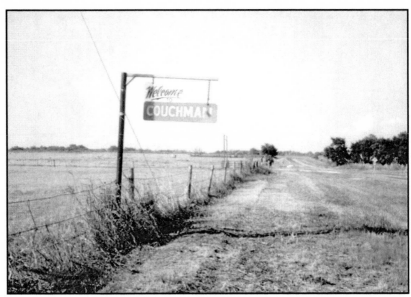

Couchman, Texas, birthplace of Blind Lemon Jefferson.

Author at the approximate site of the Jefferson farm, where Blind Lemon was born.

Shiloh Primitive Baptist Church, Kirvin, Texas, where the Jefferson family—including Blind Lemon—worshiped.

Author interviews Charlie and Mattie Dancer of Streetman, Texas, while Mick Knight sings a Blind Lemon song.

Timothy Carter of Fairfield, Texas, who knew Blind Lemon.

Roosevelt Black of Fairfield, Texas, who knew Blind Lemon.

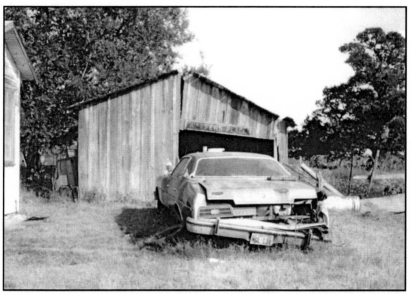

The Waffers lived next door to the Jeffersons at Couchman.

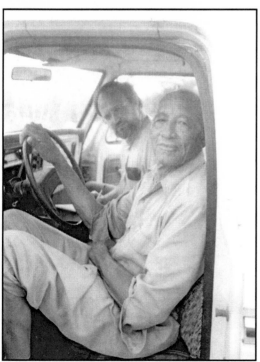

Hobart Carter, who married Lula Bell Waffer, at the Waffer farm at Couchman, where he lived until recently. Today, Carter is 103 years old and lives in an apartment in Wortham.

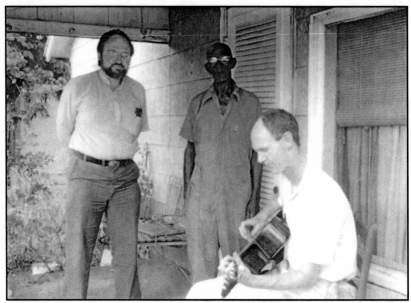

Author (left) and Quince Cox listen to Mick Knight sing a Blind Lemon song.

Arthur Carter of Wortham reading the author's Living Blues *article on Blind Lemon Jefferson, whom he knew.*

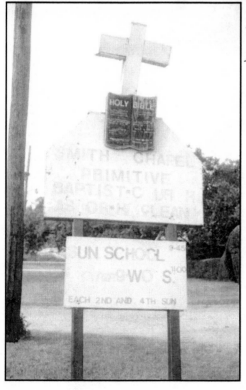

Smith Chapel Primitive Baptist Church, Wortham, Texas, site of Blind Lemon's funeral, January 1, 1930.

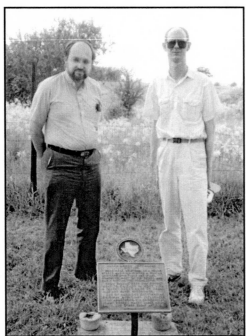

*1967 Texas Historical
Marker above grave of
Blind Lemon Jefferson at
Wortham Black Cemetery.*

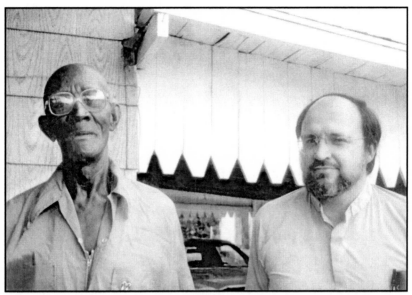

Author with cemetery caretaker Quince Cox, who knew Blind Lemon.

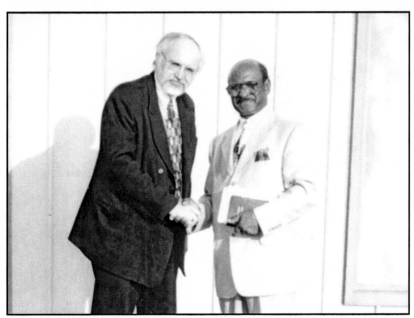

Author and Rev. Howard McLean, pastor of Smith Chapel Primitive Baptist Church in front of renovated building at Homecoming—September 23, 2001.

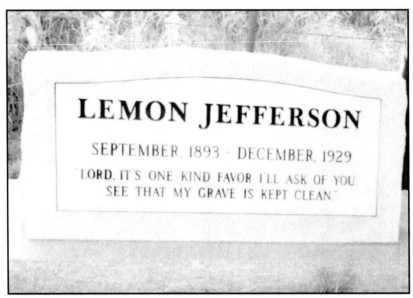

Headstone erected at Blind Lemon's gravesite in 1997.

Author standing behind the 1997 headstone.

Author and Joe Butcher in front of Blind Lemon Jefferson Community Center in Wortham.

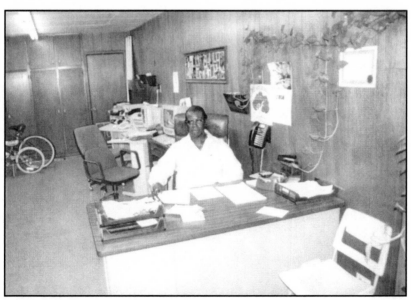

Joe Butcher, co-manager of BLJ Community Center, at his desk.

Library of BLJ Community Center.

Joe Butcher views antique china donated to BLJ Community Center.

Dining room of BLJ Community Center.

Heirlooms donated to center by families of deceased Wortham residents.

More heirlooms.

More heirlooms.

Outside BLJ Community Center.

Pianos at BLJ Community Center.

Outside Blind Lemon Urban Bar and Bistro, Deep Ellum, Dallas.

Inside Blind Lemon Bar.

Author beside picture of a Dallas political event in Blind Lemon bar, Dallas. There are no pictures of Blind Lemon Jefferson at this place of entertainment.

K. M. Williams, the "Blues Preacher."

producer and who had been so informed by his office assistant. Laibly heard that Lemon died during a blizzard. This information was later substantiated by Williams, who stated that the singer had collapsed in his car and was abandoned by his chauffeur.[4] There was also a story that he left the party drunk and got lost as he tried to make his way through the streets in the cold winter night.[5]

Mance Lipscomb recalled what he heard about Blind Lemon's death:

> Blind Lemon had just been paid off a lot of money in cash by two big record companies and he wanted to go to the depot there in Chicago and catch a train home. Being a blind man he needed someone to guide him to the depot. Whoever started out guiding him didn't finish the job. Anyway somebody knocked him in the head and took his poke with all that record money in it and left my friend in the cold, cold street to freeze to death.[6]

Mattie Barree Dancer, alone among many interviewees, stated that she heard that Lemon was shot during a performance or got too hot and then went outside and could not handle the shock caused by the sudden change in temperature.[7]

Paramount hired Texas pianist Will Ezell to accompany Lemon's body to Dallas by train. Friends from Central Texas met the train in Dallas and took his body back to Wortham on Christmas Eve.[8] Apparently, his body lay in state throughout the holiday season, perhaps to give scattered relatives and friends the chance to travel to Wortham. On a bitterly cold New Year's Day 1930, his funeral was held in his hometown. According to Quince Cox, the funeral took place at Smith Chapel Primitive Baptist Church No. 1 and the eulogy was delivered by the church's pastor, Reverend Kilgo.[9] Cox's recollections included the following recounting of various theories concerning Lemon's death: "Anyone over the age of sixty remembers that day well. They brought his body back to Texas by train. People said he died in the snow after a recording ses-

sion in Chicago, that he was lost, couldn't find his way. Some thought it was foul play. Two or three hundred people came to the funeral, black and white, to watch his coffin lowered into the ground."[10] The final rites were conducted at the Wortham Black Cemetery, next to Van Hook Stubbs' cow pasture on Highway 14, between Wortham and Richland.[11] Lonnie Monings, the late husband of Della Monings of Tehuacana, attended the funeral and reported that the casket was kept closed and the ground was frozen.[12] Mattie Barree Dancer stated that burial was quite difficult because "snow was backed up to the door" and had to be scraped away.[13]

During the 1950s, Samuel Charters interviewed Savannah Waffer of Couchman, who had known Blind Lemon all of his life and whose daughter had ridden with him around Wortham during his last trip home. Due to inclement weather, she and her husband, Alec, did not attend the funeral. However, they did walk across the frozen fields to spend a few hours with Lemon's mother when they heard that he was dead.[14]

In March 1930 blues singer John Byrd recorded "Wasn't It Sad About Lemon?" which confirms the traditional account of Blind Lemon's death. Byrd sang:

> Blind Lemon was born in Texas,
> A state we all know well.
> 'Twas on the streets of Chicago,
> Was where poor Lemon fell. . . .
>
> The weather was below zero
> On the day he passed away,
> But this is the truth we all know well
> That's a debt we all have to pay.[15]

The above song was released on Paramount 12945. The flip side of this record was a sermon entitled "Death of Blind Lemon," by Rev. Emmett Dickinson.[16] Reverend Dickinson was a black minister with a more liberal attitude toward blues than many of his contemporaries.[17] On this record, he preached:

I take my text from First Book of Corinthians, fifteenth chapter, forty-fourth and fifth verses, which reads as follows: "It is sown a natural body; it is raised a spiritual body"; and "So it is written that the first man Adam was made a living soul and the last man Adam was made a quickening spirit." My friends, Blind Lemon Jefferson is dead and the world today is mourning over this loss. So we feel that our loss is Heaven's gain. Big men, educated men and great men, when they pass on to their eternal home in the sky—they command our respects. But when a man that we truly love for the kindness and inspiration they have given us in our uppermost hearts pass on to their rewards, we feel that there is a vacancy in our hearts that will never be replaced. The world is in mourning over this loss. Let us pause for a moment and think of the life of our beloved Blind Lemon Jefferson who was born blind. It is in many respects like that of our Lord, Jesus Christ. Like Him, unto the age of thirty he was unknown, and also like Him in the space of a little over three years this man and his works were known in every home. Again I refer to our text: I believe that the Lord in Blind Lemon Jefferson has sown a natural body and will raise a spiritual body. When I was informed of Lemon's death, I thought of our Lord Jesus Christ as He walked down the Jericho road and saw a man who was born blind. And His disciples said: "Master, who did sin? Did this man sin or his parents, that his is a man born blind?" And Jesus Christ answered, "Neither did this man sin nor his parents sin but that I may be manifested in him." Lemon Jefferson was born blind and was cut off from the good things of this life that you and I enjoy; he truly had a cross to bear. How many of us today are crying about the crosses we are to bear: "Oh Lord, this is too hard for me; Oh Lord, I have a pain here and an ache there, and Oh Lord, my life is miserable to lead." Blind Lemon is blind. As Lemon died with the Lord, so did he live.[18]

Paul Oliver gave the following comments on the above eulogy:

The whole man still eludes us, but the Reverend Dickenson's [sic] sermon gives more than a little indication of the importance of Blind Lemon Jefferson to the Negro world of the twenties, whose members bought his records and listened to his blues; revealing a character, proud, devoid of self-pity in spite of considerable handicaps; loved and esteemed in spite of personal foibles and defects of behavior—a man in whom was "sown a natural body" with human weaknesses and appetites, but a man whose sins did not put him past redemption and whose example in his honesty, his self-examination, his forthrightness of purpose, blues singer or no, could be raised in death "a spiritual being."[19]

There is a conflicting account of Blind Lemon's death, but it is virtually without support. Blues singer Son House claimed to have met Lemon in the Paramount Studio in Port Washington, Wisconsin, the day before he recorded there in July 1930 and that, the next morning, he went to the studio with Charley Patton and Louise Johnson. According to this account, the three singers were met by recording director Art Satherly, who said, "I've got some bad news for you. Lemon was killed in a car accident early this morning."[20] The fact that the aforementioned memorial recording was done four months prior to this and the fact that the people in Wortham recalled the winter funeral negate the idea of a July death.

Thus, after having made a major contribution to the music of the 1920s, Blind Lemon Jefferson was laid to rest on the first day of the new decade.

Chapter 6

Blind Lemon Jefferson Remembered

It has been said that, for a period of twenty-five years after his death, Blind Lemon Jefferson was virtually forgotten.[1] The writer questions the truth of this statement. He feels that, while there may have been no formal recognition, the Great Depression of the 1930s caused a deeper appreciation of the blues. However, the record industry was hit hard by the depression. Paramount folded. Other companies discontinued their field trips to the South for on-the-spot recording. Many Americans, black and white, began to regard the purchase of records as a luxury. Nevertheless, the blues survived.[2] W. C. Handy wrote:

> Then the depression came, and white people suffered the pinch along with their darker brothers. With us, of course, being broke and low-down is an old story. With us there has never been anything else but depression. We have known for years how to laugh under trying circumstances, how to go on

50

living with nothing but song to sustain us. But it took a woeful depression to teach this trick to white America.

Now there seems to be a much greater appreciation for the little things of life, including music. Indeed, according to one university man, only steel and oil were larger industries than music during the worst of the depression. Proof again, if more were needed, that in times of suffering and uncertainty America must sing.[3]

During the 1950s, Samuel Charters visited the Wortham Black Cemetery in preparation of his book *The Country Blues*. At that time, Blind Lemon's grave was unmarked. However, Wortham residents recalled that his mother Classie Jefferson was buried next to him when she died in 1947.[4] During this visit to the gravesite, Charters could not help but think of Lemon's simple plea expressed in song:

> There's one kind favor I ask of you,
> One kind favor I ask of you.
> Please see that my grave is kept clean.[5]

The above lyrics are from Lemon's song "See That My Grave Is Kept Clean," an adapted version of the old southern folk song "Two White Horses in a Line," sung to the tune of "Careless Love."[6] This song contains the following additional lyrics:

> It's a long lane that got no end,
> It's a long lane that got no end,
> It's a long lane that got no end,
> And it's a bad way that don' never change.
>
> Lord, it's two white horses in a line,
> Lord, it's two white horses in a line,
> Going take me to my buryin' ground.
>
> Have you ever heard a coffin sound?
> Have you ever heard a coffin sound?

Have you ever heard a coffin sound?
Then you know the poor boy's in the ground.

Dig my grave with a silver spade,
Dig my grave with a silver spade,
Dig my grave with a silver spade,
You may leave me down with a golden chain.

Have you ever heard a church bell toll?
Have you ever heard a church bell toll?
Have you ever heard a church bell toll?
Then you know that the poor boy's dead and gone.[7]

Despite the plea "Please see that my grave is kept clean," Blind Lemon's unmarked grave received little attention for many years. Charters and a few other visitors to the cemetery noticed the grass and weeds growing around it. During the 1960s, a number of "hippies" who recognized the tremendous debt which rock 'n' roll owes to blues, came to Wortham looking for Lemon's grave.[8] In subsequent years, many other people, for various reasons, have made the pilgrimage to Wortham. Quince Cox observed: "You'd be surprised to know how many people come here to see that grave. Different people come from everywhere to look at that grave. I don't know why. Must be some gold in that grave."[9]

In July 1967 Uel L. Davis Jr. received a letter from Marilynn Hill, dean of continuing education at Southern Methodist University in Dallas, asking for information on Blind Lemon Jefferson for a biographical sketch she was writing for volume three of *The Handbook of Texas*.[10] This letter sparked Davis' interest in obtaining a historical marker for Blind Lemon's grave. Application was made to the Texas State Historical Commission, and funds were raised by the citizens of Wortham.[11]

The marker was dedicated on October 15, 1967. The dedication ceremony took place during a rainstorm marked by thunderous sound effects. Someone held an umbrella over

Mance Lipscomb as he sang "See That My Grave Is Kept Clean." When he sang the lines "Have you ever heard a church bell toll?" he fretted the neck of his guitar with the hasp of his pocketknife, with the resulting sounds resembling church bells.[12] John A. Lomax Jr., one of the most outstanding authorities on American folk music, gave the dedicatory address.[13] Following the formal ceremony, Lipscomb played some other Blind Lemon songs, including "Deceitful Brownskin Blues."[14] At the conclusion of the dedication, there was also an unusual ritual performed by five white musicians from New York.[15] This ritual involved burial of a bottle which they said contained a message to Blind Lemon and the planting of a number of brooms in the ground around the grave. The musicians said that the brooms were "something special" because they had been baptized in the Mississippi River.[16]

Davis felt that the historical marker honored one of Blind Lemon's favorite sayings—"Don't play me cheap." At the time of the dedication, there was talk of an annual blues festival at Wortham. However, no one at the time was willing to sponsor such an event. As a result, it would not materialize for another thirty years.[17]

The following chain of events led to some major changes:

In July 1996, a blues fan visiting the old cemetery posted a note to the blues-1 discussion group [an Internet discussion group for blues fans], stating that the cemetery was in disrepair and the historical marker needed sprucing up. Bruce Roberts in Austin contacted Casey Monahans at the Texas Music Office and he set the wheels in motion to repair the state marker. Bruce also suggested raising funds to place a granite marker and set up a bank account and began to solicit donations through the Internet blues group. Jeff Seale set up an Internet website with photos of the cemetery and an overview of the project. Robert Morgan [father of Blacktop Records blues artist Mike Morgan] provided an introduction to Sandra McCown, owner of Hillsboro Monument Works, a major supplier of headstones and en-

graving services in North Texas. A fan of Texas music herself, she offered to provide a nice headstone, engraving, and setup, at cost.[18]

On blues-l, many people began to express dissatisfaction that there was no headstone for one of the founding fathers of the blues. By December 1996, enough money had been collected to purchase the headstone and to make a substantial contribution to the Wortham Black Cemetery Association, the caretakers of the cemetery. This fund received a large donation from the Scandanavian Blues Association, which is based in Sweden; and from Tradition/Rykodisc Records, a company which had recently reissued some of Lemon's music on CD. Bruce Roberts visited the State Archives in Austin, where he found evidence that Lemon was born in September 1893 rather than July 1897, as previously reported. Work on the stone began in December 1996 and was completed in early 1997.[19]

The new headstone was placed at the gravesite on February 6, 1997. At this time, Bruce Roberts presented a check for the balance of the fund to Joe Butcher, president of the Wortham Black Cemetery Association.[20]

On Tuesday, September 9, 1997, the Blind Lemon Jefferson Blues Foundation was officially organized and registered with a Certificate of Assumed Name, in compliance with Chapter 36, Title 4, Business and Commerce Code of the State of Texas. Officers included Rosa Lee Quarles[21] of Wortham as president, Bobby G. Smith of Wortham as vice president and public relations director, Joe Butcher of Wortham as board manager, and Dr. E. V. Moore[22] of Teague as business manager. This certificate was notarized by Ada G. Conner of Limestone County. On Friday, September 12, 1997, this certificate was filed in the Freestone County Clerk's Office in Fairfield.[23]

The grave marker was officially dedicated on Saturday, September 13, 1997. Officiating at this ceremony were two distant relatives of Blind Lemon—Rev. Curtis Jefferson Jr. and his father, Curtis Jefferson Sr. They were joined by Elder L. A.

Davis, who led the group in a song and prayer. This ceremony was attended by approximately twenty blues fans, some coming from Austin, Dallas, and Houston.[24]

After the ceremony was completed, the Wortham Area Chamber of Commerce sponsored the first annual Blind Lemon Jefferson Blues Festival. On this day, the two-block-long business district was blocked off for the concert and a lighted stage was set up on the east end of the street. Food concession booths were available along the street. Musicians performing included Diamondback, the All Stars, Lee Van Wagner and Mark Blampied, the Imperial Gospel Singers, Jim Suhler and Alan Hayes, the Javaheads, Tim Wheeler and the Soul Shufflers, and George Spratt and the Spratt Attack.[25] Among the many T-shirts worn by fans in attendance was one which asked "Why did it take so long?"

The festival was a reasonable success, raising more than $3,000 to be used for renovation of Lemon's gravesite and assurance that, in the future, all of the graves at the cemetery will be "kept clean."[26] The festival is now an annual event, held during the second weekend in September.

In 1998 Joe Butcher and Wortham teacher and coach Joe Randle purchased a two-story building at 106 West Main Street in Wortham. On February 15, 1999, the Blind Lemon Jefferson Community Center opened. This center provides daycare to the elderly, charging $6 per hour or $25 for all day, with meals included. Each day after school, children come to the center to do their homework, work on computers, and participate in recreational activities. The building contains many heirlooms, including $47,000 worth of antiques donated by families of deceased Wortham residents.[27]

Blind Lemon Jefferson: Prince of Country Blues is the name of a musical theater production written by Alan Govenar, the author of *Meeting the Blues* and of *Deep Ellum and Central Track,* in collaboration with Akin Babatunde. Its purpose is to "bring to life the myth and legend of the man and his music." Govenar explained: "As a mechanism for moving the action forward and telling the story, we created what we call a blues

chorus; kind of Greek like, blues chorus. The story unfolds from the perspective of someone trying to find out more information about Blind Lemon and going down to Wortham. In many ways it is inspired by my own experiences working on *Meeting the Blues*." This production, which was directed by Babatunde, ran from May 27 to June 12, 1999, in the Experimental Theater, located in the basement of the Majestic Theater on Elm Street in Dallas. The role of Blind Lemon was played by David Peaston, a contemporary rhythm and blues and gospel singer from Saint Louis. The guitar work was performed offstage by Paul Young.[28] Two years later, this production appeared for a second time, at the Watermark Theater in the Dallas suburb of Addison.

On Saturday, September 8, 2001, the Fifth Annual Blind Lemon Jefferson Blues Festival—the biggest ever—was held in Wortham. By this time, the list of sponsors had grown to include the following: Wortham EDC, T&B Thomason, McDonald's of Mexia and Fairfield, Porter Funeral Home, Farmers State Bank, John Vineyard, the Back Room, Protocol Fitness Systems, Mexia Chiropractic, Bottomline Bookkeeping, Rockin' L Steakhouse, D&M Pharmacy, One Hair Place, Rag Tops Salon, LeFevre Boutique, Rogers Construction, Thomason Circle Ranch, TXU Electric and Gas, Fitch Signs, Flatt Stationers, Bi-Stone Building Supply, KYCX 104.9 FM, *The Mexia Daily News,* Guaranty Bank of Mexia, HEB Food Stores, Brookshire Brothers Food Stores, the Wortham Store, Wortham Antique Mall, beauty consultant Marie Dunn, Woodson's Lumber, Cabbage Patch Daycare of Groesbeck, KDT Construction, Bobby Reed, and the First National Bank of Groesbeck. Performers included the Dan Calhoun Band, Voodoo Healin', the Robin Banks Blues Band, "Mean" Gene Kelton and the Die Hards, Andrew "Junior Boy" Jones, Rusty Martin, and K. M. Williams.

The writer was in attendance at the 2001 Blues Festival, dividing his time between the concert area and the BLJ Community Center, where he met Willie Jefferson, a cousin of Blind Lemon. On Sunday September 23, 2001, he returned to

Wortham to attend the Homecoming Celebration at Smith Chapel Primitive Baptist Church, the site of Lemon's funeral. BLJ Community Center owners Joe Butcher and Joe Randle are both active members of Smith Chapel. The current pastor is Rev. Howard McLean. From all indications, both of these September events were enjoyed by all in attendance.

Known as the "Blues Preacher," the aforementioned K. M. Williams has perfected many of Lemon's guitar techniques. He was born in Clarksville, Red River County, Texas, in 1956 and, at age seven, received a guitar lesson from a bluesman, believed to be Elmore James, who was passing through nearby DeKalb (Leadbelly's old stomping ground). However, Williams feels he did not receive the gift of composing and performing spirituals and blues until his Christian conversion in 1980. Since then, he has performed for gospel choirs, quartets, and groups, and also has played solo blues and gospel gigs. In 1995 he was ordained as a minister in the Church of God in Christ. In 1997 he organized a blues band called K. M. Williams and the Blues Train. He has opened for Robert Jr. Lockwood, Little Milton, the Holmes Brothers, and the Five Blind Boys of Alabama. As a solo artist, he has released three compact disks: "The Reverend of Texas Country Blues," "Texas Country Blues Preacher," and "Sanctified Boogie."[29]

K. M. Williams' repertoire that night in Wortham included "Black Snake Moan" and "'Lectric Chair Blues." He and the writer met for the first time at the 2001 Blues Festival and quickly became friends. On Sunday, September 16, 2001, K. M. preached at Forest Hill AME Church in Fort Worth, where the writer is pastor. His sermon was delivered less than a week after the terrorist attacks in New York and Washington, D.C. He well expressed it when he said "the whole country has the blues."[30] On Saturday, October 27, 2001, he performed a "Tribute to Blind Lemon Jefferson" during the Fairfield Sesquicentennial Celebration at the Fairfield High School Auditorium. This tribute included the songs sung in Wortham, along with "See That My Grave Is Kept Clean" and "Prison Cell Blues." Prior to his performance, he invited the writer on-

stage to promote this book. Later that evening, during a pageant of the history of Freestone County, he played the part of Blind Lemon, singing "The Blues Came to Texas."[31] K. M. is a new but good friend, and his enthusiastic efforts on behalf of this book are appreciated.

Legacy of
Blind Lemon Jefferson

Describing the legacy of Blind Lemon Jefferson, as expressed during his lifetime and in the seventy years since his death, is no simple task. During his heyday, his records sold in both the urban North and the rural South. He was quite popular among poor blacks in the urban ghettoes and among sharecroppers and levee camp workers in the South. The relationship between his music and his lifestyle has been thus described:

> Blind Lemon is almost the archetype of all bluesmen, living the rough life that is grimly portrayed in his songs, full of fluid images of violence and death, the transience of relationships, endlessly on the move, but at the same time full of humour and rugged independence. While all around the universe of his vision there is decay and social collapse, Lemon's blues have a force and resilience, sometimes in their themes of lust and sexuality but also in their ability to enter into another man's shoes, to see things from his point of

view. He was able, as the St. Louis singer Henry Townsend said, to "take sympathy with the fellow."[1]

Paul Oliver theorized concerning reasons behind the popularity of Lemon's blues:

> Frequently, Blind Lemon Jefferson's blues are termed "primitive," and in the anthropological sense of being unlettered and untutored, they are. Aesthetically, too, they may be considered the "primitive germ" . . . that fertilizes the seed of the music. But though there is not a trace of sophistication in Blind Lemon's singing or playing, there are subtle qualities of rich individuality that fortify the development of jazz music, as a young sherry is fortified by the blends that precede it. Blind Lemon's blues have a primitiveness that is in no way synonymous with crudity, but his blues were undoubtedly strong meat: full-flavored and rare without garnishings or fussy trimmings; the savor of the barbeque rather than of the chef's cuisine, making the gorge rise in the sensitive stomachs, but relished by those who delight in chitterlings and hog's maws and pigfeet. . . . Starkly dramatic, stripped of all superfluities, cruelly beautiful as the Texas landscape, Blind Lemon's recordings burn their way to the hearts of his hearers. They spring from the oil wells, they are rooted with the cane, grown with the cotton, and they lie with the dust on the Dallas sidewalks.[2]

Regarding Lemon's legacy, Bob Groom wrote:

> Some writers have described Lemon as "dirty and dissolute," others as perceptive and imaginative. However, human beings consistently refuse to fit into the stereotypes designed for them by the categorizers amongst us. The lyrics of Lemon's blues reveal a complex, fascinating personality; sometimes realistic, sometimes dreaming; sometimes peaceful, sometimes violent; and always vacillating between optimism and pessimism. A completely human person. There is

quite a lot of humour in Lemon's lyrics and he isn't afraid to laugh at himself from time to time.

Lemon was a superb singer and a magnificent guitarist, perhaps a genius on his instrument. He had a supreme talent for the translation into music of his feelings and ideas. Forty years after his death, his records are played and enjoyed in countries all round the World. No greater testimony to his art can be imagined.[3]

The music of Blind Lemon Jefferson received a boost the year after his death when the noted black poet and author James Weldon Johnson recognized the blues as "essentially folk songs" and declared them a "great repository of folk poetry." Also in 1930, poet Sterling Brown gleaned some of the best blues verses in an article in which he urged his readers to listen to available blues records, noting that many authentic folk blues were being issued on commercial records, and cited the names of a number of performers, including Blind Lemon Jefferson. In introducing his survey of the blues, he described them as invaluable documents about humanity. In 1936 Alaine Locke, with the advice of Brown, wrote a brief description of the blues, in which he defended the morality of the blues and jazz as "healthy paganism" rather than "morbid eroticism." The autobiography of W. C. Handy, which was published in 1941, contained much valuable information on early blues and later commercial developments. In 1952 Brown published another article, in which he gave many examples of more recent records and also noted the blues of white folk singers.[4] Many of the latter acknowledged the influence of Blind Lemon Jefferson.

In a letter to Uel L. Davis Jr. in preparation for the dedication of the historical marker, Larry Skoag wrote:

His legacy was tremendous! He changed the tastes of millions of Negroes and not a few whites. Jazz musicians owe Lemon a debt of gratitude because he, more than any other blues singer, incorporated the pure improvisation elements

of primitive jazz in his music. His guitar styling and his vocal treatments have been copied by hundreds of jazz people and popular entertainers. The amended list includes just a few who's [sic] music show distinct influence of Blind Lemon Jefferson.[5]

Skoag gave the following list of musicians influenced by Blind Lemon: Sam "Lightnin'" Hopkins, Lowell Fulson, Lil' Son Jackson, Mercy Dee, Black Ace, Huddie Ledbetter, Wright Holmes, Manny Nichols, Son Becky, Rob Cooper, Black Boy Shine, Bessie Smith, Victoria Spivey, Bob Wills, Milton Brown, Bill Boyd, Frank Teshmacher, Louis Armstrong, Tommy Dorsey, Harry James, and Bix Biederbecke.[6]

Blind Lemon's success as a recording artist for Paramount inspired Columbia and other record companies to record other blues singers, including Henry "Ragtime Texas" Thomas, Blind Willie Johnson, Alger "Texas" Alexander, Gene Campbell, Funny Paper Smith, Willard "Ramblin'" Thomas, Huddie Ledbetter, and Lil' Hat Jones.[7]

Tom Shaw, the Texas bluesman transplanted to California, reported meeting Blind Lemon for the first time around 1923. He saw him several times after this and readily acknowledged his influence, stating: "I didn't learn to play like Lemon until shortly after he died. . . . I stayed up all night until I got it and then I could play like Lemon."[8] John Lee Granderson of Ellendale, Tennessee, listed Lemon as one of his favorite singers and claimed to have met him.[9] Johnny Shines, who was born in Memphis on April 25, 1915, played music which has been described as a mixture of Blind Lemon, Lonnie Johnson, Scrapper Blackwell, and Charley Patton.[10]

Melvin "Lil' Son" Jackson was born in Tyler, Texas, in 1916. In the early 1930s, he moved to Dallas, where he first heard of Blind Lemon's records. He was especially influenced by "Blues Came to Texas," with its popular line "I walked from Dallas clear to Wichita Falls," a line adopted by Bob Wills and his Texas Playboys.[11] Perry Cain, who was born in New Waverly, Texas, in 1929, recalled his family listening to Blind Lemon's records.[12]

J. B. Lenoir, born the same year in Monticello, Mississippi, was taught many of Blind Lemon's songs by his father.[13] In 1932 King Solomon Hill recorded six titles for Paramount in Grafton, Wisconsin, including "My Buddy Blind Papa Lemon."[14] In 1934 Larry Hensley, a guitarist in Walker's Corbin Ramblers (a hillbilly string band), recorded a solo version of "Matchbox Blues," with lyrics, music, and vocal style almost identical to Blind Lemon Jefferson's 1927 version.[15]

In the chapter related to Lemon's Dallas years, his association with Huddie Ledbetter was discussed. While there is no evidence that they performed together after 1917, there can be no doubt that Lemon's influence continued until Leadbelly's death on December 6, 1949. In a discussion of Leadbelly's work with ARC Records during the 1930s, his biographers wrote:

> Art Satherly was an Englishman who had worked his way up through the pioneer days of recording. He was by now the company's expert on hillbilly and race records. (He would later gain fame as the man who signed up country singer Hank Williams.) Satherly obviously saw Leadbelly's commercial value as that of a blues singer, possibly as a modern-day successor to Blind Lemon Jefferson, who had died just a little over five years before. The first two days' work was full of such classic blues, including Huddie's version of one of Jefferson's best-known songs, "That Black Snake Moan." Essentially the same as Jefferson's, Huddie's version was entitled "New Black Snake Moan." Then there was "Packin' Truck Blues," Huddie's shortened version of the song Jefferson had recorded in Chicago in 1927 and called "Match Box Blues." In fact, on Huddie's last ARC session, not held until February 5, he forgot he had already done this song and recorded it a second time . . . Another song, "C. C. Rider," was derived from Jefferson's popular "Corinna Blues" from 1927. "Red River" was close in style to Blind Lemon, and later Huddie recorded his tribute song, "My Friend, Blind Lemon."[16]

During the 1940s, Blind Lemon's jazzy single-string work bore fruit in the pioneering electric blues of T-Bone Walker.[17] Walker put Lemon's style of guitar playing in front of a full orchestra and took it to California.[18] In 1943 Seth Richard and his partner, Sheffield, recorded "West Kinney Street Blues," an adaptation of Lemon's "One Dime Blues."[19] In 1954 Dr. Ross released "Going to the River," which was an updated version of "Wartime Blues."[20] During the 1950s skiffle craze in England, Lonnie Donnegan's version of "Jack O'Diamond Blues" was a hit.[21]

Lightnin' Hopkins told Frank X. Tolbert about his first encounter with Blind Lemon: "I took up with Blind Lemon Jefferson at the Buffalo Association in Buffalo, Texas, when I was eight years old. Ever since I been whipping a guitar and singing and making songs. Blind Lemon said when I played and sang I electrified people. He was the one that started calling me Lightnin'!"[22] Hopkins reportedly followed Lemon to Dallas' Deep Ellum and other gathering places for black musicians.[23] His 1959 "rediscovery" album, *The Roots of Lightnin' Hopkins,* includes a spoken reminiscence of Blind Lemon, "Penitentiary Blues," and "See That My Grave Is Kept Clean."[24]

The Texas bluesman Lowell Fulson, who had a great impact on the revitalization of rhythm and blues, was born and raised in Oklahoma, the son of a guitar-playing mother and a Cherokee father. During the early 1940s, he came to the Dallas–Fort Worth area, where he patterned his blues style after Blind Lemon Jefferson and Texas Alexander. Later, he adopted the electric guitar techniques of T-Bone Walker and Austin's PeeWee Crayton in numerous performances in Texas and Oklahoma. His hits included "Blue Shadows," "Lonesome Christmas," "Reconsider Baby," and "Every Day I Have the Blues."[25]

The influence of Blind Lemon Jefferson can be discerned in the music of Robert Pete Williams, a native of Baton Rouge, Louisiana.[26] Blind Willie McTell, probably the greatest Atlanta bluesman and master of the twelve-string guitar, is reported to have first heard the twelve-string played by Blind Lemon. Roscoe Holcomb, a white mountain musician from Kentucky, said that, until he encountered Lemon's artistry, "the blues

were only inside me; Blind Lemon was the first to 'let out' the blues."[27] Jimmie Rodgers, the white "singing brakeman" from Meridian, Mississippi, reportedly learned songs from Blind Lemon and other blues singers while working on the railroad in Texas and Louisiana.[28]

Howling Wolf, a bluesman from the Mississippi Delta, said, "What I liked about Lemon's music was that he made a clear chord. He didn't stumble in his music like a lot of people do."[29] Muddy Waters—another Delta musician—told folklorist Alan Lomax: "I been listening to blues records all my life as I can remember what the blues was. . . . Barbecue Bob and Blind Lemon Jefferson and Blind Blake, Roosevelt Sykes—they was my thing to listen to."[30] A verse from "Black Horse Blues" turned up in slightly altered form when the Mississippi singer Charley Patton recorded "Pony Blues," which included the following lyrics: "Got to get on my black horse and saddle up my gray mare." Robert Johnson—called "the king of the Delta blues singers"—borrowed from Lemon's "Change My Luck Blues" when he produced "Walking Blues." In "Walking Blues," Johnson sang: "She got Elgin movements from her head down to her toes/And she can break in on a dollar anywhere she goes."[31] Skip James, another Mississippian, resurrected the melody of "One Dime Blues" when he recorded "Sick Bed Blues." He also was known to play "Jack O'Diamond Blues."[32]

Son House recalled performing "Mississippi County Farm Blues" to the tune of "See That My Grave Is Kept Clean."[33] According to Pete Guralnick: "Lemon's music was echoed in its day by the work of Texas artists like Little Hat Jones and J. T. "Funny Paper" Smith, Alabama-born Ed Bell and Edward Thompson, white hillbilly singer Dick Justice, Mississippi bluesman Isaiah Nettles, and of course the whole extended Texas tradition and stretched down through T-Bone Walker to the enormously influential recordings of Lightnin' Hopkins after World War II and even the rhythm and blues that Duke Records put out in Houston all through the 1950s and 1960s."[34]

Little Joe Blue has spoken enthusiastically about the music of Blind Lemon Jefferson.[35] So has B. B. King, who has stated:

> I think that young musicians have a groundwork laid for them. The older ones have left something for you to build on so you build your own ideas upon that foundation, on top of what has already been built.
>
> I used to hear Blind Lemon, Lonnie Johnson, and quite a few of the older blues singers. That was real blues to me. I think most of us that started after listening to guys like Lonnie Johnson and Blind Lemon and maybe Big Joe Williams. Quite a few of the guys like that, we had to kind of come by them. We couldn't just start a new thing all of our own and not learn some of the old songs that they did way back. A lot of old blues go way back. Each generation puts its own thing to it and makes it sound a little different. But the roots are still right there and you can still feel it when you play.[36]

King said that his style was shaped "in about equal parts" by Blind Lemon, Dr. Clayton, and Samuel H. McQuery of the Fairfield Four.[37] He has often spoken of having a goal of recording an album of classic blues, including titles by Blind Lemon and other older blues artists.[38]

In a 1966 interview, Rev. Gary Davis said of Blind Lemon that "he hollered like someone was hitting him all the time" but stated that he liked Lemon's guitar playing.[39] On April 2, 1969, Roosevelt Holts released an album called *South Mississippi Blues* (Rounder 2009, 12" LP), incorporating stanzas from both "Match Box Blues" and "Long Lonesome Blues."[40]

Blind Lemon Jefferson was a southwestern bluesman who was well known and quite influential in the Southeast. Blind Willie McTell of Georgia recorded versions of Lemon's songs. Some of these were issued on a record album in 1972.[41] Charles Henry "Baby" Tate reported seeing Lemon perform in Georgia.[42] Gussie Nesbitt, a blind singer from Union, South

Carolina, recalled meeting him in Alabama.[43] Kid Prince Moore of North Carolina recorded "Bite Back Blues" with the vocal delivery much in the style of the Texas singer.[44] Otis and Percy Lassitter were Tarheel bluesmen from Northampton County who learned many of their songs from Lemon's recordings.[45]

Lemon's influence extended to the Old Dominion. Dave Dickerson was born at Tip Top, Tazewell County, Virginia, on May 4, 1913. When he was a child, his family bought Paramount records—including many by Blind Lemon—by mail order. Dickerson recalled eagerly awaiting the arrival of the mailman in order to learn new acquisitions.[46] Archie Edwards, who was born in 1918 in Rocky Mount, Franklin County, Virginia, employed guitar and vocal inflections reminiscent of Blind Lemon. His "Bear Cat Mama Blues" was derived from Lemon's "Balky Mule Blues."[47] John Cephas, who was born in Washington, D.C. on September 4, 1930, and raised in Bowling Green, Caroline County, Virginia, recorded "West Carey Street Blues," which seems to be based on "One Dime Blues," one of Lemon's most frequently copied songs.[48]

In 1961 Pete Welding put on disc a moody, gospel-tinged performance of the theme of "One Dime Blues"—"I'm broke and I ain't got a dime . . . everybody get in hard luck some-time"—by blind street singer Connie Williams. This record was called "One Thin Dime" and ended with Lemon's lyrics "This house is lonesome, my baby left me all alone . . . If your heart ain't rock, it must be marble stone."[49]

During the 1960s, a number of white rock musicians and their youthful fans became interested in the blues. Among the trend-setting rock artists who traced their musical roots directly to Texas blues were Buddy Holly, Janis Joplin, Johnny Winter, Steve Miller, and Roy Orbison. During this period, Elvis Presley recorded an adaptation of "Teddy Bear Blues."[50] Elvis also recorded a version of Little Junior Parker's "Mystery Train," which contained Lemon's line "Well, the train I ride is eighteen coaches long."[51] In 1961 pioneer folk-rock artist Bob Dylan recorded "See That My Grave Is Kept Clean" on his first album.[52] Lemon's influence on Dylan was considerable:

The liner notes on that album describe the "surging power and tragedy of Blind Lemon Jefferson's blues." The same notes claimed that the poignancy and passion of this simple song were in the finest tradition of the country blues. Dylan, future king of folk-rock and poet for the social activism of the 1960s, was also described as part of that same tradition begun so eloquently by Blind Lemon. And indeed, while listening to Lemon Jefferson's 1920s recordings, it is difficult not to hear traces of a young Bob Dylan some forty years later. The distance from the bottomlands of Central Texas to the folk clubs of Greenwich Village and from the country blues to rock 'n' roll is a short one.[53]

Carl Perkins produced a rockabilly version of "Matchbox Blues," with its memorable line "Sitting here wondering would a matchbox hold my clothes." Later, the Beatles recorded an adaptation of this blues classic, sung by drummer Ringo Starr.[54] Lemon even inspired the name of the 1960s rock group Jefferson Airplane, later known as Jefferson Starship.[55] In 1970, twenty-four songs by Blind Lemon Jefferson were released on two albums by Riverside Records.[56]

Blind Lemon's records, from the very beginning, were consumed by avid collectors of "race records," both black and white. However, from the very beginning, they also were shunned by moralists due to the suggestive lyrics of many of his songs.[57] Ray Charles once reported listening to Lemon's records "on the sly."[58] However, as a pioneer of the blues, Lemon earned a permanent place in music history. His importance as the first successful blues recording artist cannot be overstated. He has been correctly interpreted as a symbol of "all the anonymous people who may have been his contemporaries or predecessors."[59] There can be no doubt that Lemon is at the very root of American blues and, therefore, rock 'n' roll. Nearly every blues artist since has been influenced directly or indirectly by his recordings, whether they know it or not."[60]

Today, at 2805 Main Street in the once defunct and later revived Deep Ellum area, there is a nightclub called Blind

Lemon Urban Bar and Bistro. The owners were drawn to the name more because of its sound and graphic possibilities than because of a desire to honor the musician. Lemon's photograph is not among the historic pictures adorning the walls of this establishment.[61] The Blind Lemon Bar was once described as looking "all nightclub" while boasting "a surprisingly sophisticated French-Italian bistro menu." At the time, pasta, pizza, and salads were prominent during the day. On Thursday, Friday, and Saturday nights, while food was still served, a disc jockey transformed the restaurant into a dance hall for the enjoyment of patrons.[62] In 1998 the kitchen was closed. Today, the music performed includes seventies, funk, and disco but, ironically, no blues.[63]

A caricature of Blind Lemon appears each month on the inside back cover of a Swedish blues magazine called *Jefferson.* The latter depicts him in the same characteristic pose as his publicity photograph but wearing a Hawaiian-style shirt rather than a suit and tie. Editor Tommy Lofgren has depicted the singer saying such lines as "Can I change my shirt now?" and "Is the world ready for me yet?"[64]

In the concluding statement of his book *The Story of the Blues,* Paul Oliver wrote:

> "I can hear my black name a-ringin' all up and down the line," sang Sonny Boy Williamson with resentment rather than pride. The blues singer has yet to declare "I'm black and I'm beautiful and I'm Afro-American," and because the blues as song has not spoken with the voice of the new militancy, the supporters of Black Power seem to have rejected the strength within the blues. But when the National Guard are withdrawn and the police put up their batons for good, when the ghettoes have been cleared and decent homes replace them, when opportunities for jobs are truly equal and segregation is no more, black Americans may be able to look back with pride upon the creation of one of the richest and most rewarding of popular arts and perhaps the last great folk music that the western world may produce.[65]

Today, it is the duty of all right-thinking individuals, regardless of race, religion, or musical tastes, to work and pray that the day of freedom, justice, and equality envisioned by Oliver might soon come to pass. Perhaps, when it does, the blues as an important black musical form will receive a greater appreciation from a wider audience. In that day, the name of Blind Lemon Jefferson will be enshrined as one of the greatest musical benefactors of the twentieth century. Seventy years after his death, his rich music legacy abides. Let us grant him that "one kind favor." Let us not play him cheap!

DEDICATION OF

TEXAS HISTORICAL MARKER

FOR

Blind Lemon Jefferson

WORTHAM, TEXAS

October 15, 1967 **3:00 P.M.**

DEDICATION PROGRAM

Master of Ceremonies

MR. H. D. WHITAKER

Member of Freestone County
Historical Survey Committee

Invocation

REV. H. V. CHAMBERS

Pastor, Primitive Baptist Church

Presentation of Colors
Boy Scout Troop 194 Wortham

Welcome .. Hon. Harold E. Walker
Mayor City of Wortham

Introduction of Distinguished Guests . Master of Ceremonies

Introduction of Speaker Master of Ceremonies

Dedicatory Address John A. Lomax, Jr.
Folk Singer, Lecturer—Chairman Houston Folk Song Group

Unveiling of Marker John A. Lomax, Jr.

Benediction Rev. C. A. Williams
Pastor, Beulah Baptist Church

★ ★ ★

Reception following program at the Wortham Community Center

Blind Lemon Jefferson
(1897 - 1929)

Born near Wortham. As a young
street musician, played a guitar
and sang spirituals and blues.
Composed many of his songs, and
had a distinctive vocal style.
From Dallas' Deep Elm District
went to Chicago in 1920's with
a talent scout; made 79 great
jazz and blues recordings.
One of America's outstanding,
original musicians. Influenced
Louis Armstrong, Bix Beiderbecke,
Tommy Dorsey, Harry James, Bessie
Smith, and other great artists.

Recorded, 1967.

:———:

FREESTONE COUNTY HISTORICAL SURVEY
COMMITTEE

Llewellyn Notley, Chairman, Miss Sue Thornton, Hugh
Harris, J. W. Bates, Mrs. Grace Carroll, Uel L. Davis, Jr.,
Mrs. Daisy Gehrels, Hugh D. Whitaker, Mrs. R. W. Williford.

Dedication of State Historical Marker at the Grave of Lemon Jefferson

Dedicatory Speech
by John A. Lomax Jr.
Wortham, Texas
15 October 1967

We are here today to acknowledge our debt to Lemon Jefferson, familiarly known as "Blind Lemon." Belatedly we gather at his grave to do honor to this man whose music contributed so much to folk blues and to jazz not only in America but throughout the world. Historically he was among the first and still ranks as one of the finest of the Negro blues composers and singers. During these attainments a nice by-product was the entertainment and happiness he brought to many people.

Many historians state that our country's virile growth has come from the diverse character of its people, its folk. Our

mighty nation has been developed by our people: their sinews have tilled our soil, their industry has built our buildings, their ingenuity has conceived our many inventions, and their courage has won our wars. And in the hands of our folk lie our hopes for a better future.

The sociological history of America recognizes that the culture of its people is best expressed by their folklore; their folk sayings and jokes, their folk dramas, tales, crafts and by their folk music. Yes, especially the songs, which truly and completely reveal the emotions of the singers and reach out to those of the listeners. Our country enjoys a great heritage of our old folk songs and has come to appreciate their historical and cultural value; our young poets compose new songs today. As the country grows, it sings, and I say, thank goodness, that *America sings.*

Most of us know that Blind Lemon was born in this neighborhood in 1897 in the time when the folk songs of its people were considered unimportant. He lived until late 1929, and during his life span we came to realize that our native music should be a vital part of our lives. Jefferson played an important role in this period of growth and acceptance of our folk music. His handicap of blindness developed more acutely Blind Lemon's remaining senses of hearing, smell and touch. It is said that he could play active games with the other children or could even follow animals at a run without accident. As he grew up he realized that most occupations were closed to him, that he would exist only as a poorly paid artisan doing dull work, as a beggar or as a musician. Perhaps he first heard the guitar locally at some gathering or from some itinerant Mexican or Negro laborer, but he took readily to this versatile instrument. Since nature's compensation provided Blind Lemon with highly developed senses of touch and sound, his playing ability quickly became proficient. His services as an entertainer were soon in demand in and around Wortham, Groesbeck, Fairfield, and Buffalo.

About 1915, greater opportunities beckoned in Dallas, and Jefferson became a fixture there, particularly in the barrel

houses and sporting establishments on upper Elm Street. With his country background of privation and his personal handicap, it followed that his motif became the Blues, the natural song type of bad luck and hard times with instant appeal to his listeners. He became a composer of new songs, skilled at improvising and bonding the songs of others to his style. Lemon played regularly in Dallas with Huddie Ledbetter, better known as Leadbelly, another great Negro folk artist, who readily acknowledged Blind Lemon's help and stated further: "Him and me wuz great buddies." An outstanding version of "The Cocaine Song" is a good example of their repertoire, and it goes like this:

> [Speaker Sings]
> Went down Deep Ellum and came up Main,
> Lookin' for a fellow to bum cocaine,
> And a Hi, Hi, Honey, take a whiff on me (Chorus)
>
> Take a whiff on me, take a whiff on me, and
> a ho, hi baby, take a whiff on me,
> And a hi, hi, Honey take a whiff on me.
>
> Came to a drug-store full of smoke,
> Saw a little sign sayin', no mo' coke,
> And a hi, hi, Honey take a whiff on me.
>
> You got a nickle, I got a dime,
> You buy de dope, Baby, and I'll buy de wine,
> And a hi, hi, Honey take a whiff on me.
>
> You take Mary and I'll take Mame,
> Mighty little difference, but they're not the same,
> And a hi, hi, Honey take a whiff on me.
>
> A whifferee and a whiffereye,
> Gonna be a whiffer, Boys, till I die,
> And a hi, hi, Honey, take a whiff on me.

Gonna chew my tobacco, gonna spit my juice,
Gonna love my Baby till it ain't no use,
Hi, hi, Honey, take a whiff on me.

Blacker de berry, sweeter de juice,
It takes a dark skinned woman for my particular use.
And a hi, hi, Honey, take a whiff on me.

You take Sue, and I'll take Sal—
Mighty little diff'ence between them gals,
And a hi, hi, Honey, take a whiff on me.

Oh de cocaine habit is mighty bad,
Kill eve'body it ever has had,
And a hi, hi, Honey, take a whiff on me.

Cocaine's for hosses, not for men.
De doctors say it kill you, but they don't say when,
And a hi, hi, Honey take a whiff on me.

In his later travels through Texas and much of the South, Lemon came in contact with many other good blues men, among them such outstanding singers as T-Bone Walker, Josh White, Texas Alexander, Smokey Hogg, Lonnie Johnson, and Sam "Lightnin'" Hopkins. All those musicians bear Blind Lemon's imprint.

Jefferson was discovered commercially in 1925 by Mayo Williams, a scout for The Paramount Record Co. of Chicago, and, until his death, he cut 140 songs for it. These 70 records, jacketed in a distinctive lemon color, included such hits as "Match Box Blues," "Black Snake Moan," "Tin Cup Blues," "Penitentiary Blues," and "Broke and Hungry." Blind Lemon hit the dead center of realism in such lyrics; his guitar pictures the casual laborer with an ironic comment that no one has since bettered.

In those days the means of distribution of records were somewhat sketchy. I am told that many hundreds of his

records were carried South out of Chicago by Pullman porters for resale at each station as the trains stopped. Playing the songs of Blind Lemon on the phonograph was a principal form of entertainment to many members of his race. Jefferson's records sold into the millions, many made the hit parade of the day, and they broke the trail for the recordings of later Negro folk artists.

In Lemon's day the successful white jazz artists specialized in race music. Harry James, Benny Goodman, Bix Beiderbecke and others listened to and were influenced by his records. Louis Armstrong, Bunk Johnson, and Jelly Roll Morton were among the Negro jazz musicians who acknowledged Jefferson's help in developing their styles. Thus, according to some authorities, the whole course of American jazz, which has spread and become popular all over the world, followed Blind Lemon's steps.

It is fitting now to play Blind Lemon Jefferson's greatest hit song. [Speaker plays taped recording of "One Kind Favor— Please See That My Grave Is Kept Clean."] In the rich phrasing of these verses, Lemon Jefferson imagined, and perhaps, secretly hoped for, a magnificent funeral. In view of this man's humble funeral and of his grave before us, untended, unkept and unmarked these thirty-eight years past, his wish has been ironic. It is fitting that this strong desire of Blind Lemon Jefferson, the front-runner of all of our great blues singers, for a suitable grave, be at last fulfilled. In his memory it is now my great pleasure to unveil the historical plaque given in his honor by the State of Texas officially to mark his grave. This monument and marker locate the place he returned, but his greatest memorial lives on forever in the melodies he made. May he rest in peace!

Endnotes

CHAPTER 1

1. Alan Govenar, *Meeting the Blues* (Dallas, Tx.: Taylor Publishing Co., 1988), 9.

2. Samuel Charters, *The Bluesmen: The Story and the Music of the Men Who Made the Blues* (New York: Oak Publications, 1967), 183.

3. Peter Guralnick, *Feel Like Going Home: Portraits in Blues and Rock 'n' Roll* (New York: E. P. Dutton and Company, 1971), 21.

4. Ibid. Today almost no black musician of any prominence will deny his blues heritage.

5. Tilford Brooks, *America's Black Musical Heritage* (Englewood Cliffs, N.J.: Prentice Hall, 1984), 56-59.

6. Arnold Shaw, *The World of Soul* (New York: Cowles Book Company, Inc., 1970), 11.

7. Guralnick, *Feel Like Going Home,* 27.

8. Larry Willoghby, *Texas Rhythm, Texas Rhyme: A Pictorial History of Texas Music* (Austin, Tx.: Texas Monthly Press, 1984), 37.

9. David Evans, *Big Road Blues: Tradition and Creativity in the Folk Blues* (Berkeley, Ca.: University of California Press, 1982), 40.

10. Ibid., 40-41.

11. Ibid., 41. This was the case during the 1960s, when many American youth involved in the so-called counterculture developed an interest in the blues and became intrigued with Blind Lemon Jefferson and other blues singers. Black activist Eldridge Clever observed this and pointed out that rock 'n' roll music represented not only an implied social commitment on the part of American youth but also their explicit embrace of a black subculture which had never previously risen to the surface. As Peter Guralnick, a white youth of

this period, expressed it: "Blues appealed to something deep seated and permanent in myself, it just sounded right to me"; see Guralnick, *Feel Like Going Home,* 9-10.

12. Jeff Todd Titon, *Early Downhome Blues: A Musical and Cultural Analysis* (Urbana, Ill.: University of Illinois Press, 1977), 32.

13. Ibid., 31.

14. Govenar, *Meeting the Blues,* 3.

15. Stephen Calt, *I'd Rather Be the Devil: Skip James and the Blues* (New York: Da Capo Press, 1994), 88.

16. Titon, *Early Downhome Blues,* 33.

17. Govenar, *Meeting the Blues.*

18. Perry Bradford, *Born with the Blues* (New York: Oak Publications, 1965), 11.

19. Charles Wolfe and Kip Lornell, *The Life and Legend of Leadbelly* (New York: HarperCollins, 1992), 89.

20. Peter Grammond, ed., *The Decca Book of Jazz* (London: Frederick Muller, Ltd., 1958), 24.

21. Evans, *Big Road Blues,* 10.

22. Ibid., 166.

23. Ben Sidran, *Black Talk* (New York: Holt, Rinehart, and Winston, 1971), 83.

24. Evans, *Big Road Blues,* 168-69.

25. Willoughby, *Texas Rhythm, Texas Rhyme,* 37.

26. Ibid., 38.

27. Charters, *The Bluesmen,* 166-67.

28. Ibid., 170.

29. Ibid., 174.

30. Richard Middleton, *Pop Music and the Blues: A Study of the Relationship and Its Significance* (London: Victor Gollancz, Ltd., 1972), 66.

31. Govenar, *Meeting the Blues,* 5.

32. Ibid., 1.

33. Bill Minutaglio, "The State of the Blues," *Dallas Morning News* (August 26, 1984): 6C.

CHAPTER 2

1. Samuel Charters, *The Country Blues* (New York: Rinehart and Company, Ltd., 1959), 59. Mattie Barree Dancer recalled that

Classie Jefferson was a heavy-set, very dark woman with a very strong voice whom everyone called "Aunt Classie." Mattie Barree Dancer. Interview by author. September 9, 1989.

2. Wolfe and Lornell, *The Life and Legend of Leadbelly,* 43. Recent research has revealed that Lemon was born in 1893 rather than in 1897, as older sources claim and as is inscribed on the 1967 historical marker above his grave.

3. Alan B. Govenar and Jay F. Brakefield, *Deep Ellum and Central Track: Where the Black and White Worlds of Dallas Converge* (Denton, Tx.: University of North Texas Press, 1998), 62.

4. Quince Cox. Interview by author. September 2, 1989.

5. Hobart Carter. Interview by author. September 2, 1989.

6. Charters, *The Country Blues,* 59.

7. Wolfe and Lornell, *The Life and Legend of Leadbelly,* 43. Mattie Barree Dancer recalled that when Lemon would hear the voice of someone he knew, he was known to say, "You sure do look good." Mattie Barree Dancer. Interview by author. September 9, 1989.

8. Quince Cox. Interview by author. August 7, 1988.

9. Pearline Monings. Interview by author. January 4, 1992.

10. Kathryn Ervin Jefferson. Interview by author. July 28, 1990.

11. Mattie Barree Dancer. Interview by author. September 9, 1989.

12. Hobart Carter. Interview by author. August 7, 1988. At the age of 103, Carter moved into an apartment in Wortham. The cornerstone to Shiloh Primitive Baptist Church states that this congregation was founded in 1866 by Rev. Bornie Moffett and that the church was rebuilt in 1922 by Rev. A. T. Thomas. Revs. A. R. Foreman, R. C. Butcher, N. J. Jackson, J. H. Clay, and E. L. Livingston are listed as former pastors. At the time of the laying of the cornerstone to the current edifice on April 6, 1969, Rev. T. W. Medlock was pastor, J. O. Proctor, H. P. Foster, Aaron Butcher, and R. C. Nevels were deacons, E. Hollie was secretary, and L. Carter was treasurer. The cornerstone was laid by Saint Andrew Lodge No. 112, A.F.&A.M., with George Warren serving as worshipful master and Aaron Butcher serving as secretary.

13. Cordell Butcher. Interview by author. March 10, 2001.

14. Larry Skoag. Letter to Uel L. Davis Jr., August 27, 1967.

The transcript is part of the estate of the late Uel L. Davis Jr., who worked for many years as Wortham's postmaster. Skoag, a Houston folklorist, was consulted by Davis, who, as chairman of the Freestone County Historical Survey Committee, applied for the historical marker above the grave of Blind Lemon Jefferson.

15. Charters, *The Country Blues*, 254-55.

16. Ibid., 59.

17. Arthur Carter. Interview by author. August 7, 1988.

18. Frank X. Tolbert, "Blind Lemon Called Physical Prodigy, Too," *Dallas Morning News* (December 26, 1971): 41A.

19. Giles Oakley, *The Devil's Music: A History of the Blues* (New York: Taplinger Publishing Company, 1976), 74.

20. Mattie Barree Dancer. Interview by author. September 9, 1989.

21. Willie Mae Thomas. Interview by author. October 13, 1990. Ms. Thomas stated that, during her younger years, Ms. Banks "would rather dance than eat" and received numerous whippings from their grandmother for going dancing on Saturday night.

22. R. L. Thomas. Interview by author. July 28, 1990. He recalled that his first drink of whiskey was given to him by a white man named Fagan at a country ball.

23. Govenar and Brakefield, *Deep Ellum and Central Track*, 69.

24. Ibid., 72-73.

25. Ibid., 74.

26. Ibid., 73-75.

27. Arthur Carter. Interview by author. August 7, 1988. Carter's late wife Sadie was the sister of Lula Spence Banks, wife of Izakiah ("Nit") Banks, half-brother of Blind Lemon Jefferson.

28. Charters, *The Bluesmen*, 189.

29. Bob Groom, "Blind Lemon Jefferson," *Blues World III* (March 1970):1-2. Groom cited two exceptions to this: the use of the knife-style guitar accompaniment in open D on "Jack O'Diamonds" and the following of the Leroy Carr original version of "How Long, How Long Blues."

30. John Holder. Interview by author. January 5, 1992. Bridge Street, along with most of the Waco Square, was destroyed by a tornado on May 11, 1953.

31. Ibid.

32. Clarice Holder Saul. Interview by author. January 5, 1992.

33. Pearline Monings. Interview by author. January 4, 1992.

34. Wolfe and Lornell, *The Life and Legend of Leadbelly*, 43.

35. Willoughby, *Texas Rhythm, Texas Rhyme*, 39.

36. According to Uel L. Davis Jr., "That was one thing about Lemon. He'd be singing at a church one day, singing at a house of ill repute the next"; see Laura Lippman, "Davis Remembers Bluesman: Blind Lemon Jefferson Helped Pioneer Genre," *Waco Tribune-Herald* (June 2, 1983): 11A.

CHAPTER 3

1. Paul Oliver, *The Story of the Blues* (Radnor, Pa.: Chilton Book Company, 1969), 2.

2. Govenar, *Meeting the Blues*, 9.

3. Quoted in ibid.

4. Oliver, *The Story of the Blues*.

5. Willoughby, *Texas Rhythm, Texas Rhyme*, 40.

6. Wolfe and Lornell, *The Life and Legend of Leadbelly*, 43.

7. Govenar, *Meeting the Blues*, 16.

8. Wolfe and Lornell, *The Life and Legend of Leadbelly*, 43.

9. Antoinette Mitchell, "Blind Lemon Jefferson: The Blind Composer," *Mexia Daily News* (December 18, 1976): 1.

10. Paul Oliver, "Blind Lemon Jefferson," *The Jazz Review* 7 (August 1959): 11.

11. Mitchell, "Blind Lemon Jefferson: The Blind Composer," 1.

12. Charters, *The Country Blues*, 62.

13. Larry Skoag. Letter to Uel L. Davis Jr., August 27, 1967. Houston's musical outlets included the Rainbow Theater, the Eldorado Club, and the Bronze Peacock. However, Houston did not emerge as a major blues center until the late 1940s and the 1950s; see Willoughby, *Texas Rhythm, Texas Rhyme*, 40.

14. Charters, *The Country Blues*, 62.

15. Oakley, *The Devil's Music*, 74.

16. Wolfe and Lornell, *The Life and Legend of Leadbelly*, 22. During the 1920s, "Dallas Rag" was recorded by the Dallas String Band, a serenading band from Deep Ellum; see ibid., 46.

17. Oliver, "Blind Lemon Jefferson," 9.

18. Wolfe and Lornell, *The Life and Legend of Leadbelly*, 46.

19. Ibid., 45.

20. Ibid. There are several Texas communities called Silver City,

but the one in Navarro County, not far from Wortham, was more than likely the Silver City where the duo performed; see Govenar and Brakefield, *Deep Ellum and Central Track,* 64.

21. Ibid.

22. Wolfe and Lornell, *The Life and Legend of Leadbelly,* 45.

23. Ibid., 42.

24. Ibid., 45.

25. Ibid., 47.

26. Ibid., 11.

27. Govenar and Brakefield, *Deep Ellum and Central Track,* 67.

28. Jim O'Neal and Amy O'Neal, "Living Blues Interview: T-Bone Walker," *Living Blues* 11 (Winter 1972-73), 21.

29. Helen Oakley Dance, *Stormy Monday: The T-Bone Walker Story* (Baton Rouge, La.: Louisiana State University Press, 1987), 11-12.

30. Charters, *The Bluesmen,* 178.

31. Govenar and Brakefield, *Deep Ellum and Central Track,* 67.

32. Ibid.

33. Roger S. Brown, "Recording Pioneer Polk Brockman," *Living Blues* 23 (1975): 31.

34. Govenar and Brakefield, *Deep Ellum and Central Track,* 66.

35. Alex Moore. Interview by author. July 23, 1988.

36. Govenar and Brakefield, *Deep Ellum and Central Track,* 63-65. Lemon was never listed in the Dallas city directories. However, in the 1929 and 1930 editions, there is a listing for an Alex Jefferson and his wife Classie on Beal Street in South Dallas. Alex Jefferson's occupation is listed as "farmer."

37. Ibid. This Wash Phillips may have been Washington Phillips, who recorded religious songs in Dallas during the late 1920s, accompanying himself on an autoharp-like instrument called the dulceola.

38. Oliver, "Blind Lemon Jefferson," 10. It appears that Lemon's drinking began before he left Wortham. At that time, much bootlegging took place in the Couchman community and bootleg whiskey flowed freely at the picnics where Lemon performed. Arthur Carter. Interview by author. August 7, 1988.

39. Oliver, "Blind Lemon Jefferson," 10.

40. Govenar and Brakefield, *Deep Ellum and Central Track,* 63. Theaul Howard had a son by the same name who eventually retired

to nearby Ferris, Texas, and recalled that, when his father was laid out before the funeral, Blind Lemon held him up and told him to touch the body so he would never fear the dead.

41. Oakley, 130. According to Hobart Carter, Roberta was a native of Mexia. He had no information on the son. Hobart Carter. Interview by author. August 7, 1988. Some reports claim that this son was named Miles and that he grew up to be a musician; see Govenar and Brakefield, *Deep Ellum and Central Track,* 73. According to Cordell Butcher, there was a young boy at Lemon's funeral who claimed to be his son. Lemon's mother, she said, denied this claim. Cordell Butcher. Interview by author. March 10, 2001.

42. Govenar and Brakefield, *Deep Ellum and Central Track,* 63. This section of Mexia has been described as "a small-town version of Deep Ellum."

43. Charters, *The Country Blues,* 62.

44. Govenar and Brakefield, *Deep Ellum and Central Track*, 61. Another prominent customer of Model Tailors during the mid-1920s was the noted Dallas civil rights leader A. Maceo Smith.

45. Vivian Hillburn. Interview by author. January 8, 1992.

46. Robert Palmer, *Deep Blues* (New York: Viking Press, 1981), 107.

47. Ibid., 106.

48. Oliver, "Blind Lemon Jefferson," 11.

49. Govenar and Brakefild, *Deep Ellum and Central Track,* 67.

CHAPTER 4

1. Titon, *Early Downhome Blues,* 63. The 1920 recording of Mamie Smith was mentioned in chapter one. The first recording of a male blues singer was done by Sylvester Weaver in 1923. The following year, records were made by Daddy Stovepipe and Papa Charlie Jackson. None of these, however, enjoyed the commercial success of Blind Lemon Jefferson; see Palmer, *Deep Blues,* 106.

2. Titon, *Early Downhome Blues,* 63.

3. Bob Groom, "The Legacy of Blind Lemon," *Blues World* I:15.

4. Albert Murray, *Stomping the Blues* (New York: McGraw Hill Book Company, 1976), 52.

5. Govenar and Brakefield, *Deep Ellum and Central Track,* 74.

6. Wolfe and Lornell, *The Life and Legend of Leadbelly,* 44.

7. Groom, "The Legacy of Blind Lemon," I:16.

8. Robert M. W. Dixon and John Goodrich, compilers. *Blues and Gospel Records,* 1902-1943, 3rd ed. rev. (Essex, England: Storyville Publishers and Company, Ltd., 1982), 371.

9. Oliver, "Blind Lemon Jefferson," 11.

10. Stephen Calt, liner notes to *Blind Lemon Jefferson, King of the Country Blues,* Yazoo, 1069. Roosevelt Black of Fairfield was born on April 18, 1911, and grew up at Rocky Branch, between Wortham and Kirvin. He recalled that Lemon's Dodge was an Executor 6 and that Lemon took many local girls riding during his last trip home. Roosevelt Black. Interview by author. September 9, 1989.

11. Charters, *The Country Blues,* 64. According to some reports, Blind Lemon died penniless. According to Uel L. Davis Jr.: "They say his agent just cleaned his plow. . . . The family, as far as I know, didn't realize anything"; see Lippman, "Davis Remembers Bluesman," 14A. As to who has received the royalties from Lemon's records, no one in Wortham seems to know; see Frank X. Tolbert, *Tolbert's Texas* (Garden City, N.Y.: Doubleday and Company, Inc., 1983), 24. After leaving Paramount, Williams briefly and unsuccessfully ventured out on his own. He then joined Vocalion as a talent scout and began recording such artists as the old Memphis bluesman Jim Jackson, Tampa Red (Hudson Whittaker), and Georgia Tom (Thomas Dorsey). When England's Decca Records opened an American office in Chicago in 1934, this company hired Williams as a scout; see Cook, *Listen to the Blues,* 132. At Decca, he perpetuated "his decade-old notions of what made for blues hits"; see Calt, *I'd Rather Be the Devil,* 199.

12. This gentleman had the distinction of cutting the first blues record in the South. This occurred in Atlanta in 1923. His method of operation involved attending Atlanta's 81 Theater each week, visiting black churches, and recruiting off the street; see ibid.

13. Ibid., 64-66. Brockman also reported an interesting incident in which Lemon asked Rockwell for $5 and Rockwell gave him $1. According to the story, Lemon protested, "That ain't no $5 bill!"

14. Ibid.

15. Ibid., 65-66.

16. The daughter of the leader of a string band, Victoria Spivey was born in Houston on October 15, 1906, and was performing at the Lincoln Theater in Dallas at age twelve. When she recorded *Black Snake Blues,* she was not yet twenty. Her partnership with Lonnie

Johnson produced many notable recordings. In 1929 she appeared in *Hallelujah!,* an all-black film directed by King Vidor, and recorded with Henry Allen's New York Orchestra. She continued to perform through the 1930s and 1940s, including some appearances in vaudeville. She died in New York on October 3, 1976; see Paul Oliver, Max Harrison, and William Bolcom, *The New Grove Gospel, Blues and Jazz, with Spirituals and Ragtime* (New York: W. W. Norton and Company, 1986), 58.

17. Daphne Duval Harrison, *Black Pearls: Blues Queens of the 1920s* (New Brunswick, N.J.: Rutgers University Press, 1988), 9.

18. Charters, *The Bluesmen,* 183.

19. Michael Taft, *Blues Lyric Poetry: An Anthology* (New York: Garland Publishing Company, 1983), 127.

20. Harrison, *Black Pearls,* 151.

21. Victoria Spivey, "Blind Lemon and I Had a Ball," *Record Research* 76 (May 1966): 9.

22. Dixon and Goodrich, *Blues and Gospel Records,* 372.

23. Giving a chronological description of the travels of Blind Lemon Jefferson is an impossible task. It is quite possible that some of his trips occurred during his Dallas years, but evidence indicates that the majority occurred after he had moved to Chicago.

24. Charters, *The Bluesmen,* 184.

25. Peter Guralnick, *The Listener's Guide to the Blues* (New York: Facts on File, Inc., 1982), 51.

26. Margaret McKee and Fred Chisenhall, *Beale Black and Blue: Life and Music on Black America's Main Street* (Baton Rouge, La.: Louisiana State University Press, 1981), 161.

27. Oakley, *The Devil's Music,* 129.

28. Groom, "Blind Lemon Jefferson," 2.

29. Mike Ledbitter, ed. *Nothing But the Blues: An Illustrated Documentary* (London: Hanover Books, 1971), 239-42. This contradicts the story of Blind Lemon's Sunday singing reported by T-Bone Walker in the previous chapter. It is possible that Lemon performed only spirituals at the Walker family's house in Dallas. This seems highly improbable, however, due to the presence of alcoholic beverages at such visits. Did Lemon have a stronger belief in "keeping the Sabbath" in his later years? The answer to this question, like many others related to Blind Lemon Jefferson, will probably always remain a mystery.

30. "Interview with Houston Stackhouse," *Living Blues* 17 (1974): 20-21.

31. Groom, "Blind Lemon Jefferson," 2.

32. Groom, "The Legacy of Blind Lemon," I:35.

33. Oliver, "Blind Lemon Jefferson," 11.

34. John S. Otto and Augustus M. Burns, "Black and White Cultural Interaction in the Early Twentieth Century South: Race and Hillbilly Music," *Phylon* 35 (December 1974): 414.

35. Evans, *Big Road Blues,* 75.

36. Charters, *The Country Blues,* 65.

37. Groom, "The Legacy of Blind Lemon," XII:19.

38. Dixon and Goodrich, *Blues and Gospel Records,* 372. "Sunshine Special" has been described as a fantasy built on the idea of the "railroad of my own" line which was prominent in early blues; see Groom, "The Legacy of Blind Lemon," XII:19.

39. Dixon and Goodrich, *Blues and Gospel Records,* 372. The Texas historical marker erected above Lemon's grave in 1967 has been interpreted as a belated response to this plea.

40. Groom, "The Legacy of Blind Lemon," XII:19. The final verse to this song contains the words "God showed Noah the rainbow sign, no more water but the fire next time," which also are part of a song often sung in black churches today. These words inspired the black author James Baldwin with the title to his book *The Fire Next Time.*

41. Titon, *Early Downhome Blues,* 204-5.

42. Guralnick, *The Listener's Guide to the Blues,* 24.

43. Charters, *The Bluesmen,* 177.

44. Titon, *Early Downhome Blues,* 254.

45. Charters, *The Country Blues,* 54.

46. Palmer, *Deep Blues,* 414.

47. Oliver, "Blind Lemon Jefferson," 11.

48. Dixon and Goodrich, *Blues and Gospel Records,* 373.

49. It might be argued that blindness is a type of imprisonment. It is easy to understand how it would make an individual more empathetic with other types of human suffering.

50. Taft, *Blues Lyric Poetry,* 131.

51. Titon, *Early Downhome Blues,* 255.

52. Ibid.

53. Dixon and Goodrich, *Blues and Gospel Records,* 373.

54. Charters, *The Country Blues,* 66.

55. Ibid.

56. Paul Oliver, *Screening the Blues* (London: Cassell and Company, Ltd., 1968), 34.

57. Ibid., 31.

58. Dixon and Goodrich, *Blues and Gospel Records,* 373-74.

59. Lippman, "Davis Remembers Bluesman," 14A. Reportedly, Lemon's chauffer was a Wortham native named Kirven Butcher, whose nephew is now co-owner of the Blind Lemon Jefferson Community Center in Wortham. Joe Butcher. Interview by author. June 2, 2001.

60. Taft, *Blues Lyric Poetry,* 134.

61. Dixon and Goodrich, *Blues and Gospel Records,* 374.

62. Wolfe and Lornell, *The Life and Legend of Leadbelly,* 44.

63. Govenar and Brakefield, *Deep Ellum and Central Track,* 76.

64. Charters, *The Country Blues,* 66.

CHAPTER 5

1. The exact date of his death is unknown. There was no death certificate found at the Cook County Courthouse in Chicago when a search was made in 1967. According to Lemon's friend and fellow blues singer Mance Lipscomb: "To them Chicago polices, Blind Lemon was just another black man found dead on the street. They didn't figure any court record was needed." Frank X. Tolbert, *Tolbert's Texas* (Garden City, N.Y.: Doubleday and Company, Inc., 1983), 24.

2. Charters, *The Country Blues,* 66.

3. Charters, *The Bluesmen,* 190.

4. Govenar and Brakefield, *Deep Ellum and Central Track,* 76.

5. Charters, *The Bluesmen,* 191.

6. Tolbert, *Tolbert's Texas,* 24.

7. Mattie Barree Dancer. Interview by author. September 9, 1989.

8. Charters, *The Bluesmen,* 66.

9. Quince Cox, Interview by author. August 7, 1988.

10. Govenar and Brakefield, *Deep Ellum and Central Track,* 76.

11. Lippman, "Davis Remembers Bluesman," 14A.

12. Della Monings. Interview by author. January 4, 1992.

13. Mattie Barree Dancer. Interview by author. September 9, 1989.

14. Charters, *The Country Blues,* 71. Hobart Carter is the son-in-law of Alec and Savannah Waffer, both of whom are deceased, as is Carter's wife. Hobard Carter. Interview by author. August 7, 1988.

15. Ibid.

16. Ibid.

17. In January 1930 the sermon "Is There Harm in Singing the Blues?" was recorded by Rev. Emmett Dickinson and the Three Deacons on Paramount 12924. Titon, *Early Downhome Blues,* 277.

18. Oliver, "Blind Lemon Jefferson," 12.

19. Charters, *The Bluesmen,* 191.

20. Ibid.

Chapter 6

1. Lippman, "Davis Remembers Bluesman," 14A.

2. Cook, *Listen to the Blues,* 133.

3. W. C. Handy, *Father of the Blues: An Autobiography,* ed. Arna Bontemps (New York: Macmillan Company, 1941), 232.

4. Charters, *The Country Blues,* 69-70.

5. Ibid., 70.

6. Ibid. "Two White Horses in a Line" was sung by many singers in Mississippi and was also known to be sung in the Carolinas and Georgia; see Charters, *The Bluesmen,* 178-79.

7. Ibid. When Blind Lemon performed this song, at the words "Have you ever heard a church bell toll," he would strike the bass strings of his guitar to resemble a slow tolling of a death blow.

8. Lippman, "Davis Remembers Bluesman," 14A.

9. Richard U. Steinberg, "See That My Grave Is Kept Clean," *Living Blues,* November/December 1988, 25.

10. Marilynn Hill, Letter to Uel L. Davis Jr. July 5, 1967.

11. Lippman, "Davis Remembers Bluesman," 14A.

12. Tolbert, *Tolbert's Texas,* 24.

13. Uel L. Davis Jr., "Blind Lemon Jefferson" from *History of Freestone County, Texas* (Fairfield, Tx.: Freestone County Historical Commission, 1978), 207.

14. Tolbert, *Tolbert's Texas,* 24. Effort had been made to arrange for Lightnin' Hopkins' participation in the dedication cere-

mony. However, because he was performing in Europe at the time, Hopkins was unable to come; see ibid., 5.

15. Ibid., 6.

16. Tolbert, "Blind Lemon Called Physical Prodigy, Too," 41A.

17. Lippman, "Davis Remembers Bluesman," 14A.

18. Don O., "Finally! A Grave Marker for 'Blind' Lemon Jefferson," http://www.glade.net/~blind lemon/history.htm, 1-2.

19. Ibid., 2.

20. Ibid.

21. This outstanding lady was born in the Freestone County community of Butler on August 4, 1914, and moved to Wortham as a child. She is the daughter of Bessie Woodard Sumuel, the granddaughter of Sally Ann Durham Woodard, and the great-granddaughter of Minor Durham. Rosa Lee Quarles. Interview by author. August 25, 2001. Minor Durham was the brother of Allen Durham, the great-great-great-grandfather of Debra Bass Uzzel, the wife of the writer. Rosa Lee and Debra are seventh cousins. Minor and Allen were sons of an African named Gobi who was enslaved in Fairfield County, South Carolina. The writer is currently working on a book entitled *The Durhams of Fairfield: An African American Genealogy.*

22. This very talented gentleman and long-time friend of the writer is employed at the Mexia State School and owns Moore's Angelic Funeral Home in Teague. An outstanding musician, he played the organ at the writer's wedding on February 19, 1977.

23. Freestone County Records.

24. Ibid.

25. "Blues Musicians Honor Native of Wortham Area," *Fairfield Recorder,* September 18, 1997, 1A. The author, who attended this festival, is a good friend of George Spratt and was a member of the Paul Quinn College faculty while George was a student there.

26. Norris Buchmeyer, "Ode to Blues: Blind Lemon Jefferson," ac.uk/~broonie/cave/misc/blind.html, 3.

27. Joe Butcher. Interview by author. June 2, 2001.

28. Bill Fountain, "The Music as Metaphor: Alan Govenar Brings Blind Lemon to the Theater," *Southwest Blues,* June 1999, 13.

29. K. M. Williams Biography, http://swbell.net/kdwilent/kmbio.htm, 1.

30. K. M. Williams. Interview by author. September 16, 2001.

31. The pageant included the following ten scenes: Indian Family, Frontier Family, the Reliance Steamboat, Old South Scene, Confederate Soldiers, Cabin Scene, Auctioneer Scene, Oil Field Scene, and Prohibition Scene. K. M. Williams appeared during the Cabin Scene. He was presented by Rose Nemons, an African American woman from Teague, who told how Freestone County blacks, many of whom remained loyal to the South, nevertheless longed for their freedom. She then described the achievements of local African Americans, including Blind Lemon Jefferson.

CHAPTER 7

1. Oakley, *The Devil's Music,* 1.
2. Oliver, "Blind Lemon Jefferson," 12.
3. Groom, "Blind Lemon Jefferson," 3.
4. Evans, *Big Road Blues,* 95.
5. Larry Skoag. Letter to Uel L. Davis Jr., August 27, 1967.
6. Ibid.
7. Bill Minutaglio, "The Blues Grew Up: The Texas Sound Influenced Many." *Dallas Morning News,* August 27, 1984, 2F.
8. Lou Curtiss, "Tom Shaw Talks." *Living Blues* 9 (Summer 1972): 24.
9. Ledbitter, *Nothing But the Blues,* 57.
10. Ibid., 62-63.
11. Ibid., 187.
12. Ibid., 195.
13. Ibid., 35.
14. Charters, *The Bluesmen,* 126.
15. Otto and Burns, "Black and White Cultural Interaction in the Early Twentieth Century South," 415.
16. Wolfe and Lornell, *The Life and Legend of Leadbelly,* 158.
17. Palmer, *Deep Blues,* 107.
18. Govenar and Brakefield, *Deep Ellum and Central Track,* 77.
19. Bob Groom, "The Legacy of Blind Lemon," *Blues World* 35 (October 1970): 19.
20. Evans, *Big Road Blues,* 121.
21. Govenar and Brakefield, *Deep Ellum and Central Track,* 77.
22. Tolbert, *Tolbert's Texas,* 19.
23. Ibid.
24. Guralnick, *The Listener's Guide to the Blues,* 45.

25. Willoughby, *Texas Rhythm, Texas Rhyme,* 75.

26. Ibid., 127.

27. Ibid., 45.

28. Bruce Cook, *Listen to the Blues* (New York: Charles Scribner's Sons, 1973), 63.

29. Oakley, *The Devil's Music,* 129.

30. McKee and Chisenhall, *Beale Black and Blue,* 235.

31. Govenar and Brakefield, *Deep Ellum and Central Track,* 77.

32. Calt, "I'd Rather Be the Devil," 93. James also sang a song called "Cypress Grove," which may have been influenced by the line "My heart stopped beatin' and my hands got cold. It ain't no more for you but the cypress grove" from Lemon's song "See That My Grave Is Kept Clean." James, however, appeared to envision an actual cypress grove rather than a graveyard; see ibid., 115.

33. Ledbitter, *Nothing But the Blues,* 26.

34. Guralnick, *The Listener's Guide to the Blues,* 26.

35. Ledbitter, *Nothing But the Blues,* 231.

36. William Ferris, *Blues from the Delta* (Garden City, N.Y.: Doubleday, 1978): 46. B. B. King has always had great love for the blues. As a result, during the mid-1960s, he experienced quite a shock when "the taste of young blacks turned against the music that he himself had been brought up on"; see Cook, *Listen to the Blues,* 199.

37. Charles Keil, *Urban Blues* (Chicago, Ill.: University of Chicago Press, 1966), 107.

38. Guralnick, *The Listener's Guide to the Blues,* 112.

39. Ledbitter, *Nothing But the Blues,* 220.

40. Evans, *Big Road Blues,* 130.

41. Bruce Bastin, *Red River Blues: The Blues Tradition of the Southeast* (Urbana, Ill.: University of Illinois Press, 1986), 138.

42. Ibid., 177.

43. Ibid., 188-89.

44. Ibid., 199.

45. Ibid., 286.

46. Ibid., 308.

47. Ibid., 316-17.

48. Ibid., 317-18.

49. Groom, "The Legacy of Blind Lemon," 19-20.

50. Bill Minutaglio, "Out of the Blues Came R&B, Rock: Texas'

Black Music Evolves from Rural Roots to Sophisticated City Sound," *Dallas Morning News* (August 28, 1984): 1E.

51. Govenar and Brakefield, *Deep Ellum and Central Track,* 77.

52. Willoughby, *Texas Rhythm, Texas Rhyme,* 39.

53. Ibid.

54. The Beatles were also greatly influenced by Lightnin' Hopkins. When they came to Houston to perform, he was the first person they asked to see. He explained, "Reason for that was that before the Beatles amounted to much, I gave them a lot of help with the guitar. They said I sort of set their heat"; see Tolbert, *Tolbert's Texas,* 19.

55. Willoughby, *Texas Rhythm, Texas Rhyme,* 39.

56. Shaw, *The World of Soul,* 13.

57. Oakley, *The Devil's Music,* 129.

58. Lippman, "Davis Remembers Bluesman," 11A.

59. Leonard Feather, *The Book of Jazz: From Then Till Now* (New York: Horizon Press, 1965), 146.

60. Don O, "Finally! A Grave Marker for 'Blind' Lemon Jefferson," 1.

61. Govenar and Brakefield, *Deep Ellum and Central Track,* 192.

62. "Good Values: Blind Lemon," *Houston Chronicle,* January 12, 1992, 1C.

63. General Manager Greg Watson. Interview by author. September 29, 2001.

64. Govenar and Brakefield, *Deep Ellum and Central Track,* 78.

65. Oliver, *The Story of the Blues,* 168.

Bibliography

BOOKS

Bradford, Perry. *Born with the Blues*. New York: Oak Publications, 1965.

Brooks, Tifford. *America's Black Musical Heritage*. Englewood Cliffs, N.J.: Prentice Hall, 1984.

Calt, Stephen. *I'd Rather Be the Devil: Skip James and the Blues*. New York: Da Capo Press, 1994.

Charters, Samuel. *The Bluesmen: The Story and the Music of the Men Who Made the Blues*. New York: Oak Publications.

———. *The Country Blues*. New York: Rinehart and Company, Ltd., 1959.

Cook, Bruce. *Listen to the Blues*. New York: Charles Scribner's Sons, 1973.

Dance, Helen Oakley. *Stormy Monday: The T-Bone Walker Story*. Baton Rouge, La.: Louisiana State University Press, 1987.

Dixon, Robert M. W., and John Goodrich, compilers. *Blues and Gospel Records, 1902-1943,* 3rd ed., rev. Essex, Eng.: Storyville Publishers and Company, Ltd., 1982.

Evans, David. *Big Road Blues: Tradition and Creativity in the Folk Blues*. Berkeley, Ca.: University of California Press, 1982.

Ferris, William. *Blues from the Delta*. Garden City, N.Y.: Doubleday, 1978.

Govenar, Alan. *Meeting the Blues*. Dallas, Tx.: Taylor Publishing Co., 1989.

——— and Jay F. Brakefield. *Deep Ellum and Central Track: Where the Black and White Worlds of Dallas Converge*. Denton, Tx.: University of North Texas Press, 1998.

Grammond, Peter, ed. *The Decca Book of Jazz*. London: Frederick Müller, Ltd., 1958.

Guralnick, Peter. *Feel Like Going Home: Portraits in Blues and Rock 'n' Roll*. New York: E. P. Dutton and Company, 1971.

———. *The Listener's Guide to the Blues*. New York: Facts on File, Inc., 1982.

Handy, W. C. *Father of the Blues: An Autobiography*. New York: Macmillan Company, 1941.

Harrison, Daphne Duval. *Black Pearls: Blues Queens of the 1920s*. New Brunswick, N.J.: Rutgers University Press, 1988.

History of Freestone County, Texas. Fairfield, Tx.: Freestone County Historical Commission, 1978.

Keil, Charles. *Urban Blues*. Chicago, Ill.: University of Chicago Press, 1966.

Ledbitter, Mike, ed. *Nothing But the Blues: An Illustrated Documentary*. London: Hanover Books, 1971.

McKee, Margaret, and Fred Chisenhall. *Beale Black and Blue: Life and Music on Black America's Main Street*. Baton Rouge, La.: Louisiana State University Press, 1981.

Middleton, Richard. *Pop Music and the Blues: A Study of the Relationship and Its Significance*. London: Victor Gollancz, Ltd., 1972.

Murray, Albert. *Stomping the Blues*. New York: McGraw Hill Book Co., 1976.

Oakley, Giles. *The Devil's Music: A History of the Blues*. New York: Taplinger Publishing Co., 1976.

Oliver, Paul. *Screening the Blues*. London: Cassell and Company, Ltd., 1968.

———. *The Story of the Blues*. Radnor, Pa.: Chilton Book Co., 1969.

———, Max Harrison, and William Bolcom. *The New Grove Gospel, Blues and Jazz, with Spirituals and Ragtime*. New York: W. W. Norton and Co., 1986.

Palmer, Robert. *Deep Blues*. New York: Viking Press, 1961.

Shaw, Arnold. *The World of Soul*. New York: Cowles Book Co., Inc., 1970.

Sidran, Ben. *Black Talk*. New York: Holt, Rinehart, and Winston, 1971.

Taft, Michael. *Blues Lyric Poetry: An Anthology*. New York: Garland Publishing Co., 1983.

Titon, Jeff Todd. *Early Downhome Blues: A Musical and Cultural Analysis*. Urbana, Ill: University of Illinois Press, 1977.

Tolbert, Frank X. *Tolbert's Texas*. Garden City, N.Y.: Doubleday and Co., Inc., 1983.

Willoughby, Larry. *Texas Rhythm, Texas Rhyme*. Austin Tx.: Texas Monthly Press, 1984.

Wolfe, Charles, and Kip Lornell. *The Life and Legend of Leadbelly*. New York: HarperCollins, 1992.

ARTICLES

Brown, Roger S. "Recording Pioneer Polk Brockman." *Living Blues* 23 (1975): 31.

"Good Values: Blind Lemon," *Houston Chronicle,* January 12, 1992, 1C.

Groom, Bob. "Blind Lemon Jefferson: Blues World Booklet No. 3." Cheshire, U.K.: *Blues World,* 1970.

———. "The Legacy of Blind Lemon." *Blues World* I-XII.

"Interview with Houston Stackhouse." *Living Blues* 17 (1974): 20-21.

Lippman, Laura. "Davis Remembers Bluesman: Blind Lemon Jefferson Helped Pioneer Genre." *Waco Tribune-Herald* (June 2, 1983): 11A.

Minutaglio, Bill. "The State of the Blues." *Dallas Morning News* (August 26, 1984): 1C.

Mitchell, Antoinette. "Blind Lemon Jefferson: The Blind Composer." *Mexia Daily News* (December 18, 1976): 1.

O'Neal, Jim, and Amy O'Neal. "Living Blues Interview: T-Bone Walker." *Living Blues* 11 (Winter 1972-73): 21.

Otto, John S., and Augustus M. Burns. "Black and White Cultural Interaction in the Early Twentieth Century South: Race and Hillbilly Music." *Phylon* 35 (December 1974): 414.

Spivey, Victoria. "Blind Lemon and I Had a Ball." *Record Research* 76 (May 1966): 9.

Steinberg, Richard U. "See That My Grave Is Kept Clean." *Living Blues* (November/December 1988): 24-25.

Tolbert, Frank X. "Blind Lemon Called Physical Prodigy, Too." *Dallas Morning News* (December 26, 1971): 41A.

Uzzel, Robert L. "Music Rooted in the Texas Soil: Blind Lemon Jefferson." *Living Blues* (November-December 1988): 22-23.

INTERVIEWS

Browne, P. D. Interview by author. January 28, 1984.

Butcher, Cordell. Interview by author. March 10, 2001.

Carter, Arthur. Interview by author. August 7, 1988.

Carter, Hobart. Interview by author. August 7, 1988.

Cox, Quince. Interview by author. September 9, 1989.

Dancer, Mattie Barree. Interview by author. September 9, 1989.

Hillburn, Vivian. Interview by author. January 8, 1992.

Holder, John. Interview by author. January 5, 1992.

Jefferson, Kathryn Ervin. Interview by author. July 28, 1990.

Monings, Della. Interview by author. January 4, 1992.

Monings, Pearline. Interview by author. January 4, 1992.

Moore, Alex. Interview by author. July 23, 1988.

Quarles, Rosa Lee. Interview by author. August 25, 2001.

Saul, Clarice Holder. Interview by author. January 5, 1992.

Thomas, R. L. Interview by author. July 28, 1990.

Thomas, Willie Mae. Interview by author. October 13, 1990.

Watson, Greg. Interview by author. September 29, 2001.

Williams, K. M. Interview by author. September 16, 2001.

MISCELLANEOUS

Calt, Stephen. *Linear Notes to Blind Lemon Jefferson, King of the Country Blues*. Yazoo, 1969.

Skoag, Larry. Letter to Uel L. Davis Jr. August 27, 1967.

Index

Abe and Pappy Club, 22
Ace, Black, 62
"Alabama Bound," 10
Alexander, Alger "Texas," 12, 21, 62, 64, 78
"All I Want Is That Pure Religion," 32
All Stars, 55
Angelina's Bar, 19
ARC Records, 63
Armstrong, Louis, 62, 79
Ashford, R. T., 29
Ashley, Clarence, 37
Atlanta, Georgia, 33

Babatunde, Akin, 55-56
"Baby, Take a Look at Me," 10
"Bad Luck Blues," 33
"Balky Mule Blues," 39, 67
Banks, Billie, 16
Banks, Clarence, 12
Banks, Izakiah, 12
Banks, Nit C., 28
"Barbershop Blues," 43
Barree, Bessie, 14
Barrow, Nettie, 16
Bates, Deacon L. J., 32, 37
"Bear Cat Mama Blues," 67
"Beat, the," 28
Beatles, 68
Becky, Son, 62
"Bed Spring Blues," 43
"Begging Back," 30, 32
Biederbecke, Bix, 62, 78
Bell, Ed, 65
Big Brown Power Plant, 16
Big Four Club, 24

"Big Night Blues," 42
"Bite Back Blues," 67
"Black Horse Blues," 32, 65
"Black Snake Blues," 34-35
"Black Snake Dream Blues," 37
"Black Snake Moan," 57
Blacktop Records, 53
Blackwell, Scrapper, 62
Blake, Blind, 65
Blampied, Mark, 55
Bland, Bobby "Blue," 10
"Blind Lemon Blues," 26
Blind Lemon Jefferson Blues Foundation, 54
Blind Lemon Jefferson Blues Festival, 56
Blind Lemon Jefferson Community Center, 55, 56-57
Blind Lemon Jefferson: Prince of Country Blues, 55
Blind Lemon Urban Bar and Bistro, 68-69
"Blind Lemon's Birthday Record," 41
"Blind Lemon's Penitentiary Blues," 18, 39
Blue, Little Joe, 66
blues: and blind singers, 7-8; and the church, 4-6, 15, 19; country, 2; development of, 1-4; and radio, 38; Texas style, 1, 8-11
"Blues Came to Texas," 58, 62
Bob, Barbecue, 65
Bob Wills and his Texas Playboys, 62
Boerner, Fred, 39
boll weevil, 24
"Booger Rooger Blues," 33

"Booster Blues," 32
"Bootin' Me Bout," 43
Boyd, Bill, 62
Bradford, Perry, 1-2
Brockman, Polk C., 33
"Broke and Hungry," 17, 32
Broonzy, Big Bill, 31
Brown Derby, 22
Brown, Milton, 62
Brown, Sterling, 61
Brown's Creek, 16
Buffalo, Texas, 15 64
Butcher, Cordell, 14
Butcher, Joe, 54, 55, 57
Butler, 16
Byrd, John, 47

"C. C. Rider," 10, 63
Cain, Perry, 62
Calhoun, Dan, 56
Campbell, Gene, 62
Carr, Leroy, 31
Carter, Arthur, 15, 18
Carter, Hobart, 14
Castille, Doc, 13
Castille Shack, 14
"Cat Moan Blues," 43
Cedar Top, 29
Centerville, 15
Cephas, John, 67
"Change My Luck Blues," 39, 65
Charles, Ray, 68
Charters, Samuel, 9, 33, 47, 51
"Cheaters Spell, The," 43
Chicago, 3, 10
Chicago Defender, 38, 41, 43, 44
"Chinch Bug Blues," 37
"Chock House Blues," 32
Christian, Charlie, 17
"Christmas Eve Blues," 41-42
city blues style, 2
classic blues, 2
Clayton, Dr., 66
"Cocaine Song, The," 77
Collin County, 20
"Competition Bed Blues," 41, 42
Conner, Ada G., 54
Cooper, Rob, 62
"Corinna Blues," 32, 63

Corsicana, Texas, 14
Couchman, Texas, 12, 14, 28, 35
Courlander, Harold, 37
Cox, Quince, 13, 46, 52
Crayton, PeeWee, 64
"Crazy Blues," 1
Crystal Springs, 36

Dallas County, 20
"Dallas Rag," 24
Dallas, Texas, 10, 20-30
Dancer, Mattie Barree, 14, 16, 46, 47
Davis, Elder L. A., 54-55
Davis, Rev. Gary, 66
Davis, Uel L., Jr., 52, 61
Davis, Walt, 37
"DB Blues," 41
"Death of Blind Lemon," 47-48
"Deceitful Brownskin Blues," 17, 37, 53
Dee, Mercy, 62
Deep Ellum, 20-22, 68
DeKalb, 57
Diamondback, 55
Dickerson, Dave, 67
Dickinson, Rev. Emmett, 47
Die Hards, 56
"Disgusted Blues," 42
"Diving Duck Blues," 36
Donnegan, 64
Dorsey, Tommy, 62
"Dry Southern Blues," 32
Duke Records, 65
Dylan, Bob, 67-68
"Dynamite Blues," 42

"Eagle Eyed Mama," 42
"Easy Rider Blues," 37
Edwards, Archie, 67
"Elder Green's in Town," 35
"Empty House Blues," 42
"English Stop Time," 35
Estes, Sleepy John, 36
Evans, David, 3, 17
Experimental Theater, 56
Ezell, Will, 46

Fairfield, 16

Fairfield Four, 66
Fairfield Sesquicentennial
 Celebration, 57
Fat Jack's Theater, 22
"Fence Breakin' Yellin' Blues," 43
Fisk University, 37
Five Blind Boys of Alabama, 57
Forest Hill AME Church in Fort
 Worth, 57
400 Club, 22
Freestone County, Texas, 12, 14, 16
Fulson, Lowell, 62, 64

Gates, Thomas, 10
General Association of Baptist
 Churches, 15
"Going to Chicago," 14
"Going to the River," 64
Goldstein, Isaac, 29
Goodman, Benny, 79
"Got the Blues," 32
Govenar, Alan, 5, 9, 22, 55-56
Granderson, John Lee, 62
Green House, 16
Greenwood, Mississippi, 36
Groesbeck, 15, 18, 25
Groom, Bob, 60
Guralnick, Pete, 65

Handbook of Texas, 52
Handy, W. C., 1, 50-51, 61
"Hangman's Blues," 18, 41
"Happy New Year Blues," 41
Harrison, Smoky, 37
Hayes, Alan, 55
"He Arose from the Dead," 37
Hearne, Texas, 23
Hensley, Larry, 63
Hill, King Solomon, 63
Hill, Marilynn, 52
Hillburn Ranch, 29
Hillburn, Vivian, 29
Hillsboro Monument Works, 53
Hogg, Smokey, 8, 78
Holcomb, Roscoe, 64
Holder, John, 19
Holly, Buddy, 67
Holmes Brothers, 57
Holmes, Wright, 62

Holts, Roosevelt, 66
"Hometown Skiffle," 44
Honey Grove, Texas, 22
Hopewell, 16
Hopkins, Sam "Lightnin'," 15, 27,
 62, 64, 65, 78
"Hot Dog," 24
"Hot Dogs," 37
House, Son, 49, 65
Houston, 23
Houston and Central Texas
 Railroad, 12
"How Long How Long," 41
Howard, Theaul, 28
Hurd, Charlie, 28

"I Don't Know What I'd Do
 Without the Lord," 19
"I Want to Be Like Jesus in My
 Heart," 32
"I'll Be Down on the Last Bread
 Wagon," 24
"Iggly Oggly Blues," 37
Imperial Gospel Singers, 55
Interurban, 24
"It's Cold in China Blues," 36
Itta Bena, Mississippi, 36

"Jack O'Diamond Blues," 32, 64,
 65
Jackson, Lil' Son, 4, 62
James, Elmore, 57
James, Harry, 62, 79
James, Skip, 65
Jamestown, Virginia, 3
Javaheads, 55
Jefferson Airplane, 68
Jefferson, Alec, 12, 16
Jefferson, Blind Lemon: birth of,
 10, 12, 54; blindness of, 13,
 15, 27, 28, 33, 48, 76; chil-
 dren of, 28; and church, 14,
 19, 36; death of, 45-46; de-
 scribed, 13, 18, 22, 23, 60;
 early influences on, 12-13; eu-
 logy for, 48-49; festival honor-
 ing, 55, 56; funeral of, 46-47;
 grave of, 51-55, 75-79; histori-
 cal marker honoring, 52-55, 71-

79; and Leadbelly, 24-26; marriage of, 28; musical style of, 2, 17, 25, 32, 33, 36, 38, 60-62; performs at clubs, 23-25, 29, 32, 36; performs at country balls, 15-16; performs on street, 13, 14, 15, 19, 21, 22-23, 26, 27, 29, 32; and prison, 39-41; pseudonym of, 32, 37; recordings of, 19, 29-30, 32-33, 34, 35, 37-38, 41-44, 45, 54, 68; song subjects of, 17-18, 26, 34-35, 39, 40-44, 51-52, 59-61, 68; success of, 1, 25, 28-29, 31, 33, 42, 43; travels of, 35-37, 66-67; as wrestler, 23
Jefferson Blues Festival, 55
Jefferson, Carrie ("C. B."), 12
Jefferson, Classie, 12, 51
Jefferson, Curtis, Sr., 54
Jefferson, Frances, 12
Jefferson, Gussie Mae, 12
Jefferson, J. W. 14
Jefferson, John, 12, 13
Jefferson, Kathryn Ervin, 14
Jefferson, Martha, 12
Jefferson, Mary, 12
Jefferson, Rev. Curtis, Jr., 54
Jefferson Starship, 68
Jefferson, Willie, 56
Jefferson, 69
Jim Crow laws, 3
Johnson, Blind Willie, 62
Johnson, Bunk, 79
Johnson, James Weldon, 38, 61
Johnson, Lonnie, 62, 66, 78
Johnson, Louise, 49
Johnson, Robert, 65
Jones, Andrew "Junior Boy," 56
Jones, Lil' Hat, 62, 65
Joplin, Janis, 67
Jubilee Singers, 37
Justice, Dick, 65

Kelton, "Mean" Gene, 56
Kilgo, Reverend, 46
Kilgore, 29
King, B. B., 66
Kirvin, 14

Kosse, 15
Ku Klux Klan, 3

"Laboring Man Away from Home," 35
Lacy, Rubin, 36
Laibly, Arthur, 45-46
Lassitter, Otis, 67
Lassitter, Percy, 67
Leadbelly, 24-26, 63, 77
"'Lectric Chair Blues," 18, 39, 40-41, 57
Ledbetter, Huddie, 24, 62, 63; *see* Leadbelly
Lee, Jake, 13
"Lemon's Cannon Ball Blues," 41
"Lemon's Worried Blues," 39
Lenoir, J. B., 62-63
Library of Congress, 26
Limestone County, 16
Lincoln Theater, 22
Lipscomb, Mance, 23, 46, 53
"Lockstep Blues," 18, 41
Locke, Alaine, 61
Lockwood, Robert Jr., 57
Lofgren, Tommy, 69
Lomax, Alan, 65
Lomax, John A., Jr., 53, 75
"Lonesome House Blues," 37
"Long Distance Moan," 43
"Long Lastin' Lovin'," 41
"Long Lonesome Blues," 32, 36, 66
"Loveless Love," 29
"Low Down Mojo Blues," 41

Ma's Place, 22
"Maltese Cat Blues," 41
Marlin, 15
Martin, Rusty, 56
"Match Box Blues," 34, 63, 66, 63, 68
Mays, Osceola, 5-7
McCown, Sandra, 53
McLean, Rev. Howard, 57
McLennan County, 19
McQuery, Samuel H., 66
McTell, Blind Willie, 64, 66
"Mean Jumper Blues," 39
Meeting the Blues, 9

Memphis, Tennessee, 3, 35
Mexia, Texas, 16, 28
Middleton, Richard, 9
Miller, Steve, 67
Milton, Little, 57
Mississippi, 10
"Mississippi County Farm Blues," 65
Mississippi Delta, 2-3, 8, 65
"Mississippi Moaner," 36
Model Tailors, 28
Monahans, Casey, 53
Monings, Della, 47
Monings, Lonnie, 47
Monings, Pearline, 13, 19
Moore, "Whistling Alex," 27
Moore, Dr. E. V., 54
Moore, Kid Price, 67
Moorhead, Mississippi, 36
Morgan, Mike, 53
Morgan, Robert, 53
Morton, Jelly Roll, 10, 79
"Mosquito Moan," 17, 43
"My Buddy Blind Papa Lemon," 63
"My Easy Rider," 35
"My Friend, Blind Lemon," 63

Navasota, Texas, 23
Negro and His Songs, The, 38
Nesbitt, Gussie, 66
Nettles, Isaiah, 36, 65
"New Black Snake Moan," 63
Nichols, Manny, 62
"Nobody There," 10

Odum, Howard B., 38
"Oil Well Blues," 42
Okeh Records, 33-34, 35
"Old Rounder's Blues," 29-30, 32
Oliver, Paul, 21, 28, 33, 48, 60, 69
"One Dime Blues," 17, 64, 65, 67
"One Kind Favor," see "See That My Grave Is Kept Clean," 79
Orbison, Roy, 67
Owens, J. H., 21

"Packin' Truck Blues," 63
Paramount Book of Blues, 38, 39
Paramount Records, 29-30, 32,
33-34, 35, 39, 43, 45, 46, 47, 50, 62, 67, 78
Parker, Shorty Bob, 37
Patton, Charley, 49, 62, 65
Paul Quinn College, 29
Peabody, Charles, 10
"Peach Orchard Mama," 17, 42
Peaston, David, 56
"Penitentiary Blues," 64
Perkins, Carl, 68
Perkins, George, 37
Phillips, Doc, 28
Phillips, Tim, 28
Phillips, Wash, 28
"Piney Woods Money Mama," 41
"Pneumonia Blues," 17, 43
"Pony Blues," 65
Port Washington, Wisconsin, 49
Post Oak, 16
Presley, Elvis, 67
Price, Sam, 22, 28, 29
"Prison Cell Blues," 18, 39, 57

Quarles, Rosa Lee, 54

"Rabbit Foot Blues," 33
Rainey, Ma, 2
"Rambler Blues," 37
Randle, Joe, 55, 57
Ransom, Roberta, 28
"Red River," 63
Richard, Seth, 64
"Right of Way Blues," 37
"Rising High Water Blues," 17, 37
Roberts, Bruce, 53, 54
Robin Banks Blues Band, 56
Robinson, Althea, 33, 45
Rockwell, Tom, 33
Rodgers, Jimmie, 65
Ross, Dr., 64
Ross, Lorenzo, 13

"Sad News Blues," 41
Saltville, Virginia, 37
Satherly, Art, 49, 63
"Saturday Night Spender Blues," 42
Saul, Clarice Holder, 19
Scandanavian Blues Association, 54

Seale, Jeff, 53
"See That My Grave Is Kept Clean," 37, 39, 51, 53, 57, 64, 65, 67
sharecropping, 3, 4
Shaw, Arnold, 2
Shaw, Richard, 37
Shaw, Tom, 27, 62
Sheffield, 64
Sheiks, Mississippi, 36
Shiloh Primitive Baptist Church, 14
Shine, Black Boy, 62
Shines, Johnny, 62
"Shuckin' Sugar Blues," 32
"Sick Bed Blues," 65
Silver City, 25
"Silver City Bound," 25
Silver Slipper, 22
Skoag, Larry, 61-62
slavery, 3
Smith, "Red" Willie, 37
Smith, Bessie, 2, 5, 31, 62
Smith, Bobby G., 54
Smith Chapel Primitive Baptist Church, 46, 57
Smith, Clara, 2
Smith, Hobart, 37
Smith, J. T. "Funny Paper," 8, 62, 65
Smith, Mamie, 1
"So Cold in China Blues," 37
soul music, 2
Soul Shufflers, 55
South Mississippi Blues, 66
"Southern Woman Blues," 43
Spivey, Victoria, 2, 27, 34-35, 62
Spratt Attack, 55
Spratt, Geroge, 55
Spratt, Horace, 37
Stackhouse, Houston, 36
Starr, Ringo, 68
Steiner, John, 45
"Stocking Feet Blues," 32
Streetman, Texas, 14
"Strip, the," 27
"Struck Snow Blues," 37
Stubbs, Van Hook, 47
Suhler, Jim, 55
"Sunshine Special," 37

Switch, Harrison, 19
Sykes, Roosevelt, 65

Tate, Charles Henry "Baby," 66
"Teddy Bear Blues," 37
Tehuacana, Texas, 13
Teshmacher, Frank, 62
Texas blues, 1, 8-11
Texas State Historical Commission, 52
"That Black Snake Moan No. 2," 42
"That Black Snake Moan," 32, 34, 63
"That Crawlin' Baby Blues," 43
Thibodeaux, James, 26
Thomas, Henry "Ragtime Texas," 8, 12, 62
Thomas, R. L., 16
Thomas, Willard "Ramblin'," 21, 62
Thomas, Willie Mae, 16
Thompson, Edward, 65
"Tin Cup Blues," 17, 23, 42
Tip Top Club, 22
"Titanic, The," 24
Titon, Jeff Todd, 5, 41
Tolbert, Frank X., 15, 64
Townsend, Henry, 60
Tradition/Rykodisc Records, 54
Trinidad, 16

Voodoo Healin', 56

Waffer, Alec, 47
Waffer, Jesse, 13
Waffer, Savannah, 47
Wagner, Lee Van, 55
Walker, Aaron "T-Bone," 17, 26, 64, 65, 78
Walker's Corbin Ramblers, 63
"Walking Blues," 65
"Wartime Blues," 32, 64
Washington, Booker T., 29
"Wasn't It Sad About Lemon?," 47
Watermark Theater, 56
Waters, Muddy, 65
Waxahachie, 16
"Weary Dog Blues," 37

Welding, Pete, 67
"West Carey Street Blues," 67
"West Kinney Street Blues," 64
Wheeler, Jim, 55
"Where Shall I Be?," 37
White, Josh, 26, 28, 78
White's Road House, 22
Williams, Ben, 5
Williams, Big Joe, 66
Williams, Clarence, 1
Williams, Connie, 67
Williams, Hank, 63
Williams, K. M., 56, 57-58
Williams, Mayo, 29, 33, 45-46, 78
Williams, Robert Pete, 64
Williamson, Sonny Boy, 69
Wills, Bob, 62

Winter, Johnny, 67
"Winter Time Blues," 36
Wolf, Howling, 65
Wortham Area Chamber of
 Commerce, 55
Wortham Black Cemetery, 47, 51
Wortham Black Cemetery
 Association, 54
Wortham Flat, 14
Wortham, Texas, 10, 12, 13, 14,
 15, 16, 42, 46, 52, 55
Yeldell, Walter, 15

"Yo Yo Blues," 43
"You Don't Know What It Means To
 Be Blind," 19
Young, Paul, 56

About the Author

Robert L. Uzzel was born May 22, 1951, in Waco, Texas, where he graduated from high school in 1969. He received an associate in arts degree from McLennan Community College, and a bachelor of arts degree, a master of arts degree, and a doctor of philosophy degree from Baylor University.

Dr. Uzzel has been a minister of the African Methodist Episcopal Church since 1975. He served as pastor of Emmanuel AME Church in Dallas, Macedonia AME Church in Kaufman, and Blooming Grove–Maypearl Circuit. He currently serves as pastor of Forest Hill AME Church in Fort Worth.

Dr. Uzzel has served as a state social worker, and as chairman of the religion department of Paul Quinn College. During the past five years, he has served as an adjunct instructor in religion and history at Mountain View College, Cedar Valley College, Temple College, Navarro College, and Tarrant County College.

His articles on theological, historical, and Masonic subjects have appeared in a number of publications. Dr. Uzzel is married to the former Debra Bass, a native of Fairfield, Texas. They have four children and six grandchildren.

LEADBELLYMUSIC@gmail.com

CPSIA information can be obtained
at www.ICGtesting.com
Printed in the USA
LVOW12s0217090317
526620LV00002B/335/P